WEST MIDLANDS RAILWAYS
RAILWAYS
THROUGH TIME

Ray Shill

Cover credits: *Front top*: R. C. H. S. Spence Collection. *Front bottom*: Author's Collection. *Back top*: Author's Collection. *Back bottom*: Heartland Press Collection.

First published 2014

Amberley Publishing
The Hill, Stroud
Gloucestershire, GL5 4EP

www.amberley-books.com

Copyright © Ray Shill, 2014

The right of Ray Shill to be identified as the
Author of this work has been asserted in accordance
with the Copyrights, Designs and Patents Act 1988.

ISBN 978 1 4456 4418 9 (print)
ISBN 978 1 4456 4431 8 (ebook)

British Library Cataloguing in Publication Data.
A catalogue record for this book is available from
the British Library.

Typeset in 9.5pt on 12pt Celeste.
Typesetting by Amberley Publishing.
Printed in the UK.

Contents

Introduction

Railways were first used for the conveyance of minerals and stone to riverside or seaside locations for onward transport by water. They were first constructed with wooden rails, but later had cast-iron rails, which were supported often by stone blocks. The first railways in the West Midlands were a pair of tracks that served coal mines at Amblecote, and were used to convey coal to the briefly navigable River Stour. Later, with the establishment of a local canal network, railways were built to convey coal, ironstone, limestone and building stone to the canal. These railed ways were laid on either stone blocks or timber sleepers. Such railways were usually private in nature, and built for a specific purpose.

Throughout Britain a network of public railways was developed during the nineteenth century. Promotion of such schemes began during the 1820s, and by the next decade had found enough support to embark on laying the first main-line routes. While the first public passenger-carrying railway operated between Liverpool and Manchester from 1830, it was the construction of the Grand Junction and London & Birmingham that created the first long distance intercity route from 1838. The meeting point of these two independent companies was Birmingham, and the construction of both lines, with necessary engineering works, was achieved in a brief period of some three–four years.

Birmingham was then a developing industrial town principally involved in working with metals to shape many everyday things, from buttons to edge tools and from decorative brass goods to guns. The new railways came to benefit the town, through the carriage of goods, parcels and passengers, complementing the already extensive canal network that served the area. The fledgling railway network was not yet in a position to provide effective competition with the canals, even if certain canal merchandise carriers became early users of the railways.

This situation, however, changed with the making of more railways. Support for the new mode of transport encouraged new railway construction as rail technology also improved to support it. Those early passenger railways were rails of cast iron set on stone blocks. This arrangement worked reasonably well for the horse-drawn mineral wagon or the odd passenger coach, but locomotive haulage was far less kind to the permanent way, and wooden sleepers came to be substituted in certain spots like embankments. Wood had the tendency to rot, but Howard Kyan developed a process called kyanisation, whereby wood was dipped in a special solution that included mercury chloride, a very effective preservative.

The preservative substances and the licence for the process were expensive, but many railway companies opted to use the method until other cheaper products (by-products of coal carbonisation) became readily available.

Another important industrial development was the improved method of making wrought iron, which had been perfected in south Staffordshire. Wrought-iron rails rolled in the mills of British Ironworks came to supersede the short cast-iron rails. Several ironmasters in south Staffordshire and east Worcestershire came to benefit from the supply of wrought-iron rails, as did other firms, who provided the chairs and fastenings.

The third useful invention applied to the mechanisation of brick making and kiln design. Where hand-made bricks burnt in semi-permanent kilns had been a feature of the early canal age, the use of machinery speeded up production and increased both the volume and quality of the brick. Also a hard engineering 'blue' brick, which was particularly suited to making railway bridges and viaducts, came to be made.

London became an early focus for railways, which radiated out from the city like points on a compass. Birmingham, too, proved to be a magnet for railway schemes. In addition to the London & Birmingham and Grand Junction, railways to Gloucester and Derby were constructed. That to Derby joined up with railways to Nottingham, Sheffield and Leeds, and placed Birmingham at the heart of an intercity rail network, a position it still holds in the present day.

Once a few railways had been made, investment in new schemes quickly developed. Like the 'Canal Mania' of 1792, a similar 'Railway Mania' became evident in the year 1845. Over the next fifteen years the bulk of the railways in the West Midlands were planned and built, creating an important network of primary, secondary and branch routes to the benefit of industry and the public. Here, as elsewhere in the country, links were often made through private investment by independent companies. At the same time, a group of select companies grew to operate them. Three companies came to serve the West Midlands; these were the Great Western Railway, the London & North Western Railway and the Midland Railway.

Those who built the railways comprised a group of semi-itinerant workers, the navvies. They had learnt their trade working on canal construction, river improvement, drainage schemes or tram roads. Organising the men and paying the wages fell to a group of contractors, many of whom had honed their skills working on making canals. West Midland railways had lines built by Thomas Townshend, Matthew Frost or John Bate, who had built local waterways. Then came a new breed of contractor, who adapted to the changing needs of railway construction as engineering projects became more and more demanding.

Private finance was also key to local and general railway development, with many schemes being proposed and built. Gradually, out of this initial explosion of building came a smaller group of operators, which slowly condensed into larger undertakings. For Birmingham and the Black Country, these numbered three: the London & North Western, Midland Railway and Great Western Railway.

1

Tram Roads, Tramways and Private Railways

Private railways were the first to be built in this region, and they continued to have a role linking industrial locations with the national network. The principal private railways comprised those that served the coal, engineering and iron industries. There were also important links for the service industries of gas making, electricity generation and water.

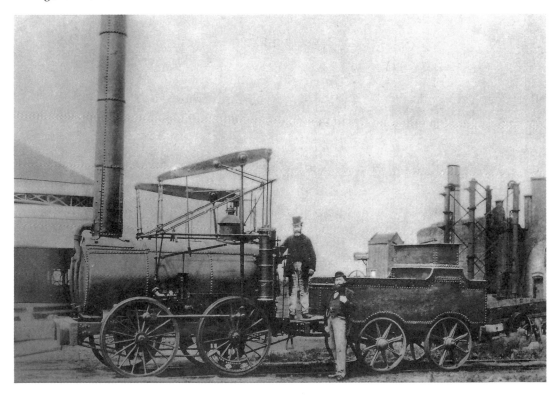

Shut End Railway
This image of *Agenoria*, built by Foster, Raistrick at Stourbridge in 1829, appears to have been taken at the Shut End Ironworks. *Agenoria* was built to work a level section of a stone block and iron railway between two inclines, which linked the Shut End Ironworks and Furnaces with the Staffordshire & Worcestershire Canal at Ashwood Basin. (Heartland Press Collection)

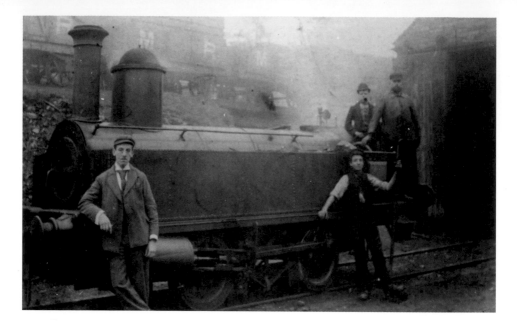

Hatherton Furnaces, Locomotive Shed, Bloxwich

George and Richard Thomas were responsible for bringing a railway link to the Hatherton Furnaces. They provided a single-track shed beside the line that crossed the Wyrley & Essington Canal to join up with the LNWR Cannock–Walsall branch. Hatherton produced pig iron for working up to finished iron. The locomotive in this view had been converted to standard gauge, but had previously worked on the 2-foot-6-inch-gauge system owned by Willenhall Furnaces, where it brought coal and ironstone from the mines to the furnaces at Sandbeds. (A. Appleton Collection)

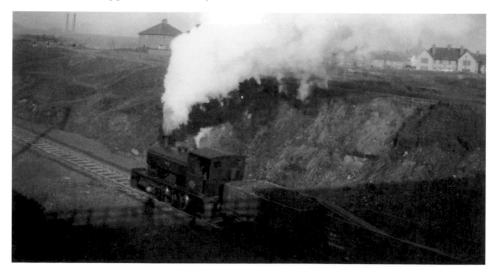

Old Park Ironworks, Wednesbury

There was a railway line that joined the Patent Shaft Steelworks with the Old Park works, which once made structural ironwork and had blast furnaces for smelting ironstone, but also made railway rolling stock, such as wagons. In this view the locomotive is working a train to the wagon works. (Doug Clayton Collection)

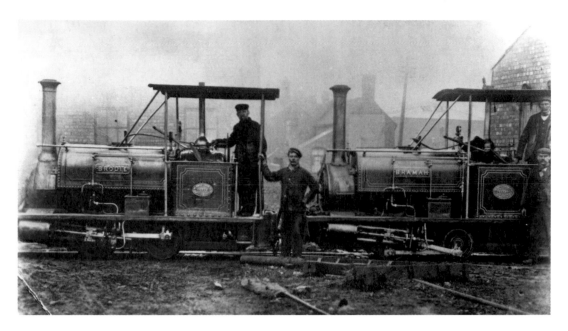

Woodside Ironworks, Brierley Hill

Cochrane's ironworks and furnaces were placed near the Dudley Canal at Woodside, and had sidings that joined the GWR. They also operated a narrow gauge system, which served their blast furnaces. (Heartland Press Collection, Ralph Russell)

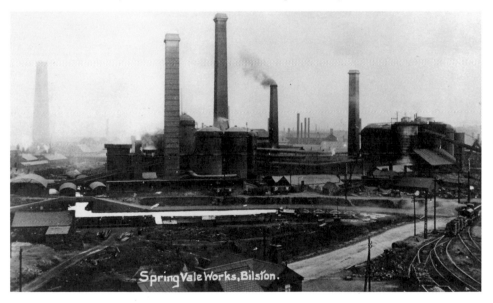

Springvale Iron and Steelworks, Bilston

Springvale iron and steelworks had a long association with iron smelting, which began in the eighteenth century. The railway links were established during the time when Alfred Hickman operated the furnaces, and their extensive system was linked to both the LNWR and GWR. Steel making began after experiments conducted in 1882 established a new process of basic steel manufacture, so that local iron could be converted into mild steel. (Heartland Press Collection)

Priorsfield Furnaces, Coseley
H. B. Whitehouse operated the Priorsfield furnaces at Coseley. These furnaces were originally only served by canal, but a railway link was made, in the 1890s, that crossed the canal, passed under the Stour Valley Railway and curved around to join it near Deepfields. (Heartland Press Collection)

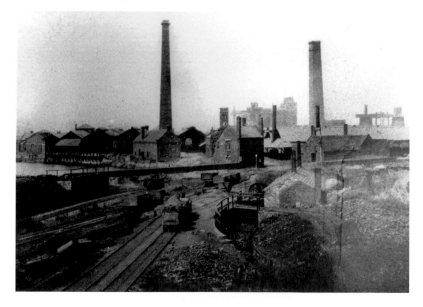

Corngreaves Furnaces, Iron and Steelworks, Cradley
The Attwoods established a steelworks at Corngreaves, and also established mines and furnaces, which were linked to the Dudley Canal by a stone block tramway. The British Iron Company and then the New British Iron Company ran the works. They had an extensive system of narrow gauge railways, some locomotive-worked, others using wire rope for incline haulage. Corngreaves was also linked by standard gauge tracks to the GWR (Stourbridge Railway). (Heartland Press Collection)

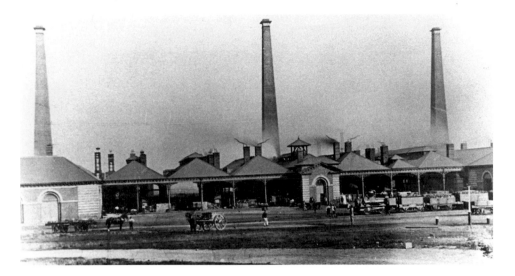

Round Oak Iron and Steelworks, Brierley Hill

Richard Smith, agent to the Earl of Dudley, was the architect of the industrial combine. He was responsible for the development of iron making at Brierley Hill and the establishment of an extensive network of private railways that were known as the Pensnett Railway. The standard gauge network fanned out from the core ironworks at Round Oak and the adjacent New Level Furnaces to mines at Cradley, Gornal, Himley and Kingswinsford. They had a number of private locomotives, including a group of four coupled tender locomotives, built by private locomotive firms such as E. B. Wilson and Manning Wardle of Leeds. They also assembled and maintained their locomotives and rolling stock at the company-owned engineering establishment at Castle Mill, Dudley. (Heartland Press Collection)

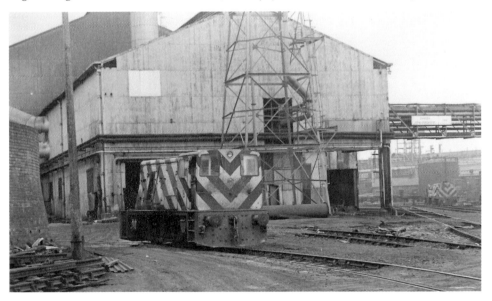

Round Oak Steelworks

Locomotives were used at Round Oak long after the complex railway network serving the mines had gone. A fleet of diesel locomotives were retained for steelworks use until 1982, when the site was closed. (Author's Collection)

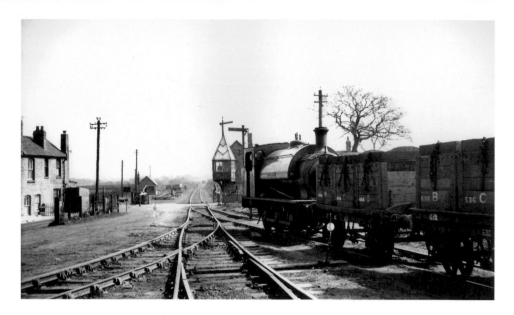

Hollybank Colliery, Essington

Most West Midlands coal mines were relatively small operations, often served by canal. A few in this district, that is Baggeridge, Hampstead, Hilton Main, Hollybank and Sandwell Park, did have railway links. The distinctive gable signal box controlled the level crossing for the coal trains that travelled from Hollybank Colliery, and later Hilton Main Colliery, through to the LNWR/LMS/BR Cannock Branch. (Jim Evans Collection)

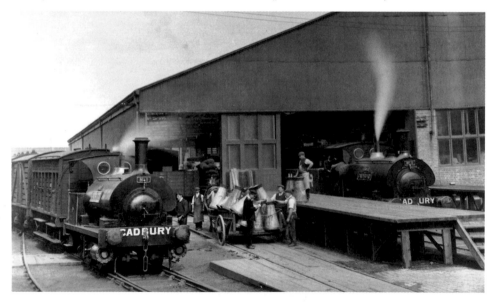

Cadbury Brothers, Chocolate Manufacturers, Bourneville

George and Richard Cadbury relocated their Birmingham chocolate factory to Bourneville, shortly afterwards establishing sidings joined with the Midland Railway (West Suburban Railway). They used both canal and railway for moving raw materials and the finished product. Their milk chocolate products at one stage had milk brought in by train. (Heartland Press Collection)

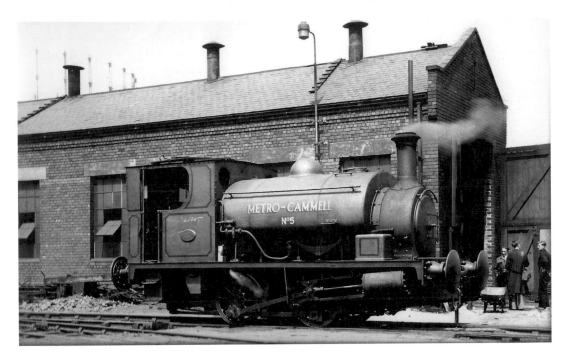

Metropolitan Cammell Wagon Works, Saltley & Brown, Marshall's Works, Adderley Park
Birmingham was noted for a group of railway carriage- and wagon-building works. One original works at Saltley eventually became the main works of the Metropolitan Carriage & Wagon Company. They also acquired the works of Brown Marshall (below), the Midland Works (Washwood Heath) and Old Park (Wednesbury). (*Above*: Industrial Railway Society, K. Cooper Collection. *Below*: Author's Collection)

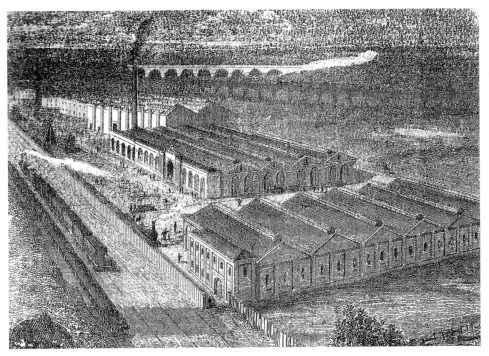

Smethwick Gasworks
Gas carbonisation to make town gas and a host of chemical by-products relied on suitable gas-making coals being transported by rail or canal. Smethwick Gasworks required a high-level railway to cross the Birmingham Canal in order to supply coal to the retort house. (Author's Collection)

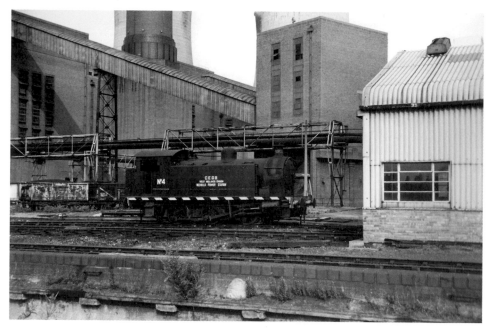

Nechells Power Station
Birmingham Corporation built its first rail-served power station at Nechells. A temporary First World War establishment was replaced by the Princes power station, which opened in 1923, using the Thomas Peckett-built steam locomotive seen in the foreground. (Author's Collection)

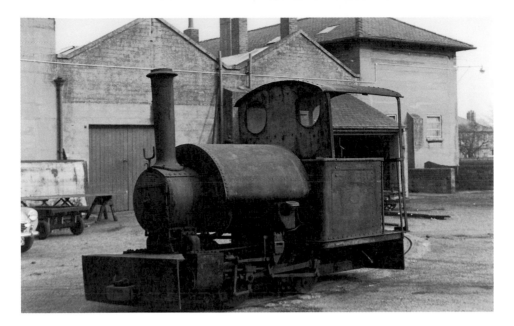

Minworth Workshops, Upper Tame and Rea Drainage Authority

There were two steam locomotives based at Minworth whose purpose was to move trainloads of ash brought from the power stations and salvage depots and deliver this cargo to the filter beds at Minworth. The railway terminated at a basin beside the Birmingham & Fazeley Canal, and crossed the Kingsbury Road on the level. The narrow railway (2-foot) system at Minworth was quite extensive, and principally internal combustion locomotives were used here to move trains of dried sludge. (Roger Hateley Collection)

Lagoon Works, Minworth, Upper Tame and Rea Drainage Authority

The bulk of the drainage authority railways served the filter beds, moving dried sludge for conversion into fertiliser. (Author's Collection)

Drift Mine, Gornal
The narrow gauge railway was commonly found in West Midland industrial locations, where the type of haulage was variable. At this mine, pit horses were used to move the pit tubs. (Professor Warwick Collection)

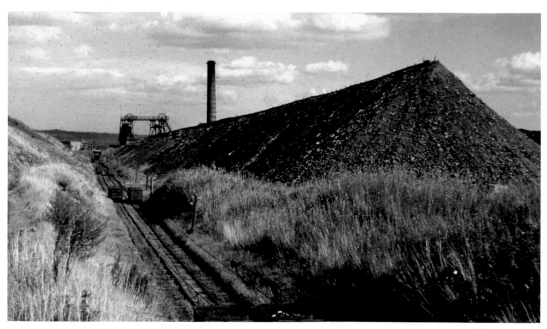

Beech Tree Colliery, near Lye
Rope haulage was used to move pit tubs from Beech Tree Colliery to Oldnall Colliery and from there to a branch siding that joined the GWR Hayes Branch. (Professor Warwick Collection)

2

London & North Western Lines

Several separate railways came to be part of the London & North Western Railway. Those that served Birmingham and the Black Country comprised:

Birmingham, Wolverhampton & Stour Valley
Grand Junction
London & Birmingham
South Staffordshire Railway

The company also worked the privately owned Harborne Railway.

During the period of ownership by the LNWR, various improvements were made to both stations and lines. Their principal improvements included the reconstruction of Walsall station, and the making of new links between Aston and Stechford and Perry Barr and Soho. Their stations often comprised both wood and brick.

From 1 January 1923, both the LNWR and Harborne Railway passed under the control of the London, Midland & Scottish Railway, and from 1 January 1948 became part of British Railways' London Midland Region.

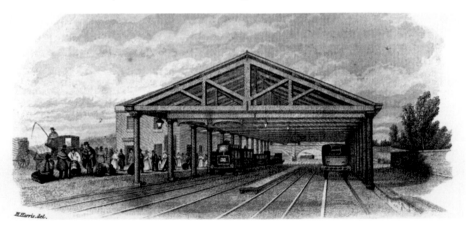

Vauxhall Station, Grand Junction Railway
The first terminus in Birmingham was placed beside Vauxhall Gardens, south of the bridge that carried Duddeston Mill Road over the railway. (Heartland Press Collection)

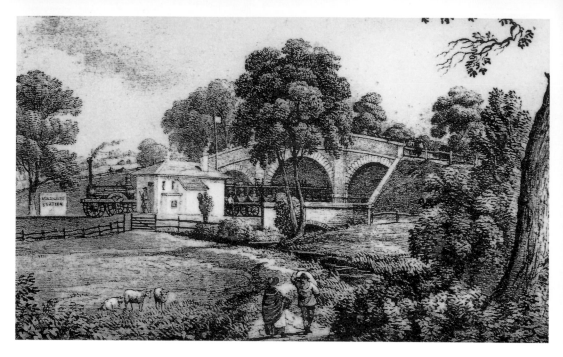

Newton Road Station, Grand Junction Railway
Many original stations on this route were both simple and basic. (Sandwell Libraries)

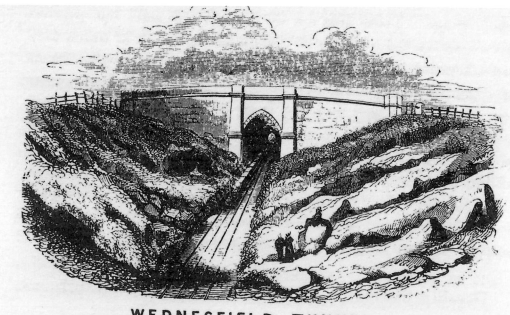

Wednesfield Tunnel, Grand Junction Railway
Construction of the Grand Junction Railway involved various engineering features, including two long viaducts at Duddeston and Aston, a canal aqueduct to carry the Walsall Canal over the railway, and a tunnel at Wednesfield. (Heartland Press Collection)

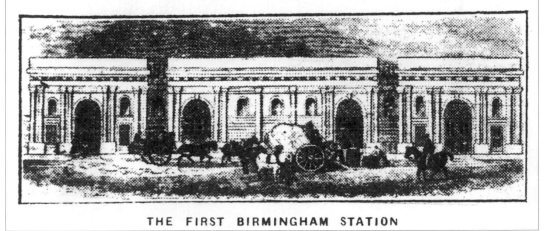

CURZON STREET STATION—"BOSOMS END"

THE FIRST BIRMINGHAM STATION

Curzon Street Station, Grand Junction Railway

Vauxhall was only a temporary terminus. With the completion of the London & Birmingham Railway, the GJR was extended to a new terminus at Curzon Street. Yet, unlike the adjacent London & Birmingham station, which faced New Canal Street, the Grand Junction station buildings were less imposing structures built along Curzon Street, south of the level crossing that carried the goods lines through to 'Top Yard'. In 1937, the *Birmingham Weekly Post* reproduced this image from Osborne's 1838 guide to the GJR, commemorating the opening of the railway to Warrington in 1837. (Heartland Press Collection)

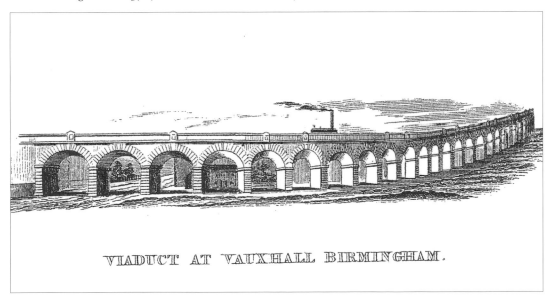

VIADUCT AT VAUXHALL BIRMINGHAM.

Vauxhall Viaduct, Birmingham, Grand Junction Railway, 1839

The former Grand Junction diverged from the London & Birmingham route by crossing the Rea Valley on a long viaduct. It was on this base that the LNWR decided to build a flyover to alleviate congestion, by passing passenger traffic destined for Sutton and Walsall over other tracks. (Heartland Press Collection)

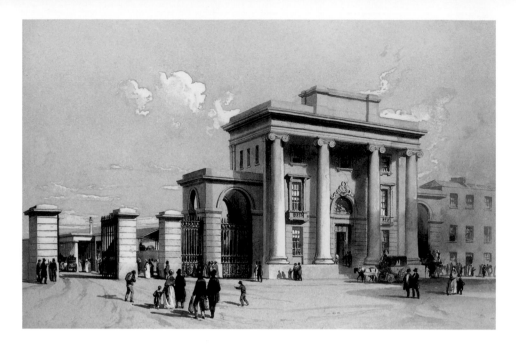

Curzon Street Station, London & Birmingham Railway
The London & Birmingham station comprised a covered train shed and an impressive group of entrance buildings. (R. C. H. S. Spence Collection)

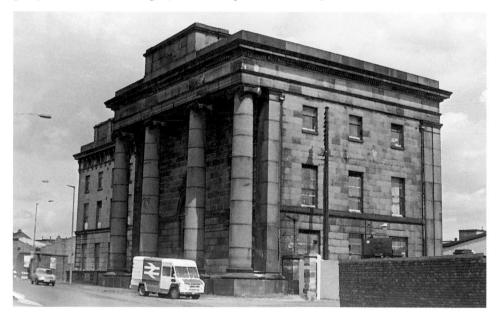

Curzon Street Station, London & Birmingham Railway
The main facade of the London & Birmingham Railway station in Birmingham was retained as a goods office for the goods station that the LNWR built on the site of the passenger station. These offices were extended on the Curzon Street side in order to deal with the organisation and process the extensive paperwork related to the LNWR goods traffic in this area. (Author's Collection)

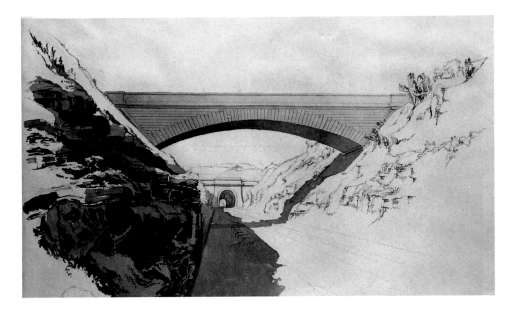

Beechwood Tunnel, Berkswell, London & Birmingham Railway

Greenshields & Cudd were the contractors for Beechwood Tunnel and the bridges towards Coventry. These structures are essentially the same today as when this engraving was made. Such were the engineering requirements of the time that, in addition to horses and men, a contractor's locomotive was required to move trains of spoil from cutting sites to make embankments on the section through Stechford, Sheldon and Berkswell. It was, perhaps, one of the earliest uses of a contractor's locomotive in this role. (R. C. H. S. Spence Collection)

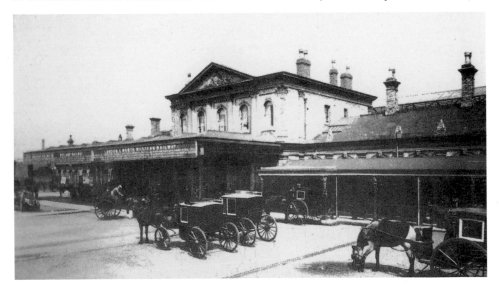

Wolverhampton High Level Station

Wolverhampton High Level station was built as a joint station for both the Shrewsbury & Birmingham Railway and the London & North Western Railway (Birmingham & Stour Valley), although the station passed entirely into LNWR control after all SBR services were transferred to the adjacent low-level station. This station building, though larger, had similar design features that can be still seen at Codsall and Albrighton stations. (R. C. H. S. Railway Post Card Collection)

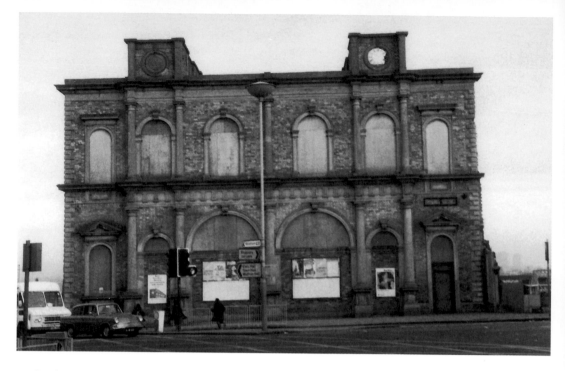

Wolverhampton High Level, Queen Street Entrance
A long drive from the station led to the imposing frontage that faced Queen Street. (Author's Collection)

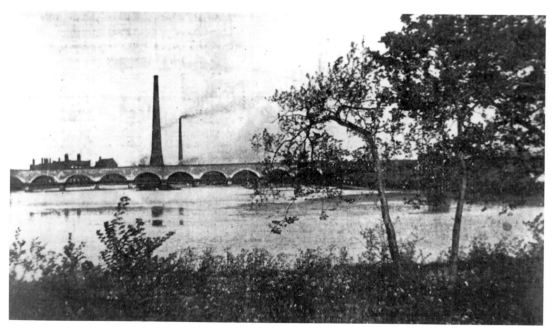

South Staffordshire Railway, Viaduct near Bescot
The South Staffordshire Railway line from Walsall to Dudley crossed Elwell's Mill Pool by a long viaduct. (Heartland Press Collection)

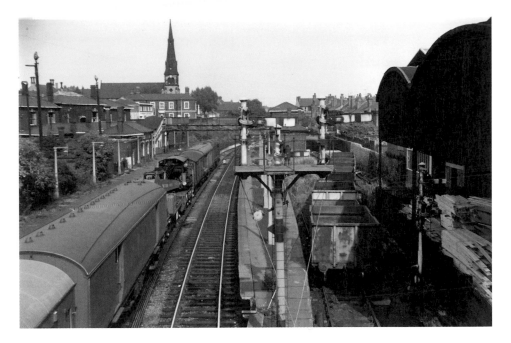

Wednesbury Station, London & North Western Railway
The South Staffordshire Railway line from Walsall to Dudley passed through Wednesbury, which had a number of industries, such as iron making, mining, structural ironwork and tube making. (Author's Collection)

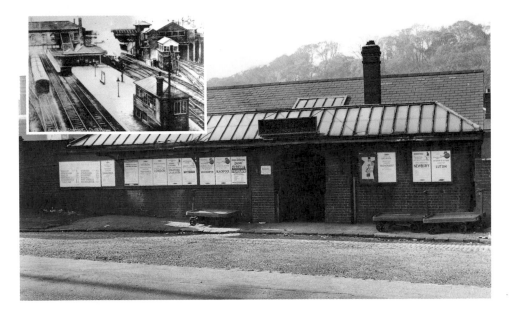

Dudley Station, London & North Western Railway
Dudley had two stations side by side. The former South Staffordshire station, which had opened first (1850) was located beside the Oxford, Worcester & Wolverhampton station placed on their main line through Kidderminster, Stourbridge and Tipton to Wolverhampton (Low Level). (Author's Collection)

Wyrley & Churchbridge Station House, London & North Western Railway
The South Staffordshire Railway line from Walsall to Cannock passed through Wednesbury, where there was a branch railway to an interchange basin with the canal at Churchbridge and later Old Coppice Colliery. These buildings faced the road, and the former level crossing was situated on the left, with the railway overbridge for the line to Cannock on the right. (Author's Collection)

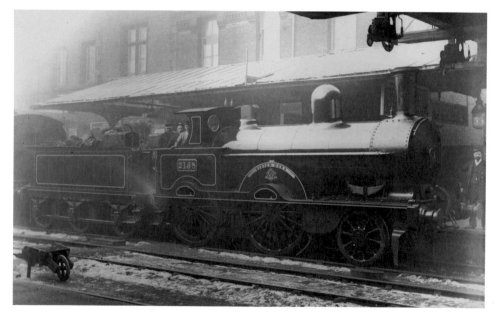

Walsall Station, London & North Western Railway
There are three periods in the development of Walsall station. The first was the making of the South Staffordshire Railway line from Dudley to Wichnor, which was completed by 1850; at this time, the main station building faced Station Street. (London & North Western Railway Society Collection)

Walsall Station, London & North Western Railway, 1969
The second stage was the widening of the tracks (1879–1883), which added additional platforms to the station and created a new circular booking hall above the tracks. In British Railways' time, the whole site was rebuilt to create a new booking office attached to the Saddlers Centre. The original South Staffordshire building remained for a time in British Railways days in order to deal with parcels traffic. (Author's Collection)

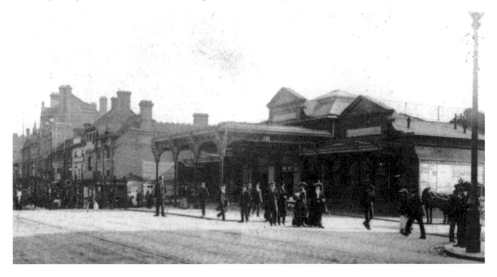

Walsall Station Frontage, Park Street
Booking office facilities were provided for both the Midland Railway and the LNWR. (Heartland Press Collection)

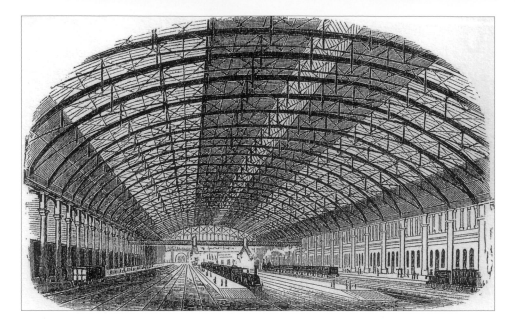

Birmingham New Street, LNWR, 1853
An overall iron roof provided by Smethwick-based structural ironwork and railway contractors Sharp, Henderson provided an important example of local engineering skills. (Cornish Guide)

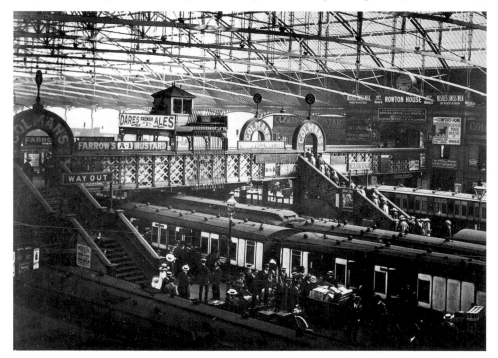

Birmingham New Street, Station Bridge, LNWR
The pedestrian thoroughfare between Stephenson Street and Great Queen Street brought people onto a central bridge that spanned the LNWR platforms. This wide bridge had steps down to the platform from either side. (R. C. H. S. Spence Collection)

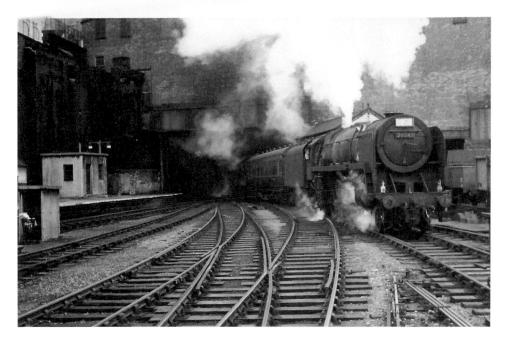

Birmingham New Street, LNWR Tunnel
The paired tunnels at the east (south) end of New Street were constructed at different times. The LNWR tunnel was made when the link between New Street and Curzon Street was completed. The second Midland tunnel (right) was made a generation later. (Heartland Press Collection)

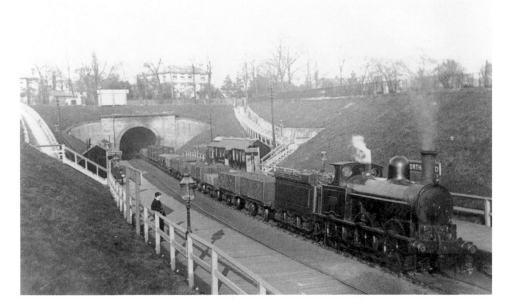

Handsworth Wood Station, London & North Western Railway
Local contractor J. Edwards was responsible for building the Aston–Stechford and Perry Barr–Soho lines, which improved railway communications in the Birmingham area and provided the means for trains to bypass the city. The route through Handsworth, which included the tunnel, was completed during 1887. (London & North Western Railway Society)

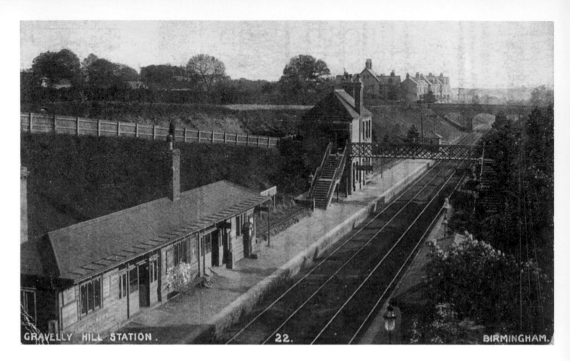

Gravelly Hill Station, London & North Western Railway
The railway from Aston to Sutton Coldfield opened with intermediate stations at Gravelly Hill, Erdington, Chester Road and Wylde Green. Most buildings were of wooden construction. (R. C. H. S. Spence Collection)

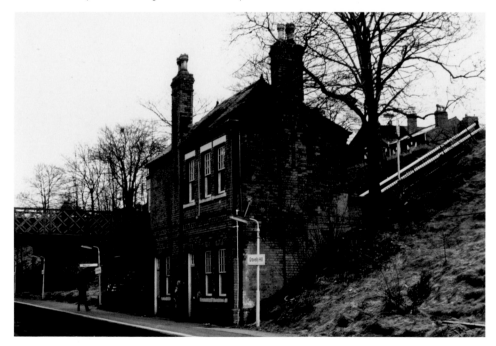

Gravelly Hill Station, London & North Western Railway
The booking office remains as a two-storey structure. (Author's Collection)

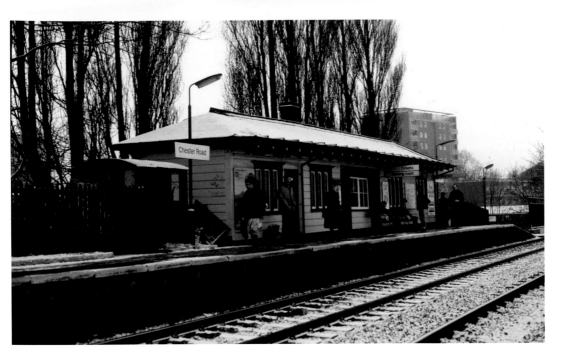

Chester Road Station, London & North Western Railway
Wooden booking offices were a feature of the LNWR Sutton Coldfield branch. At Chester Road, this combined booking office and waiting room survived from the date the station opened (1863) until reconstruction for the Cross City Electrification scheme. (Author's Collection)

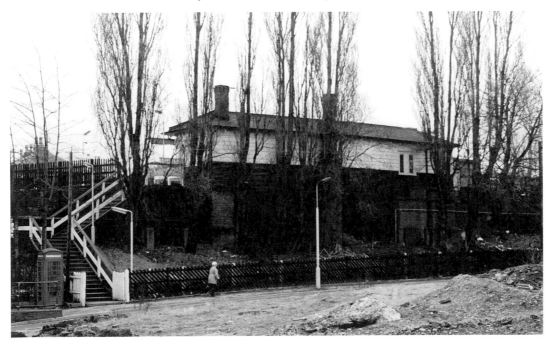

Chester Road Station, London & North Western Railway
The entrance to the station as seen from street level. (Author's Collection)

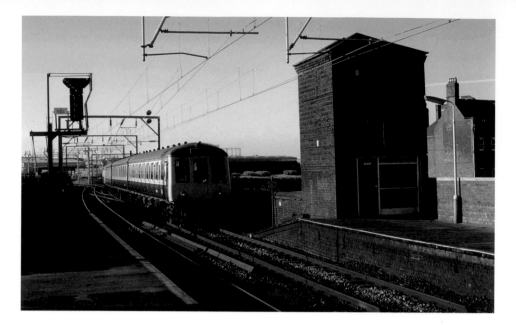

Aston Station, LNWR
Aston station was constructed on the Grand Junction Railway viaduct that crossed the Birmingham & Fazeley Canal and the Turnpike. The buildings were improved with the addition of a new booking office provided by BR at road level, and were subsequently rebuilt ready for the Cross City Electrification Scheme. (Author's Collection)

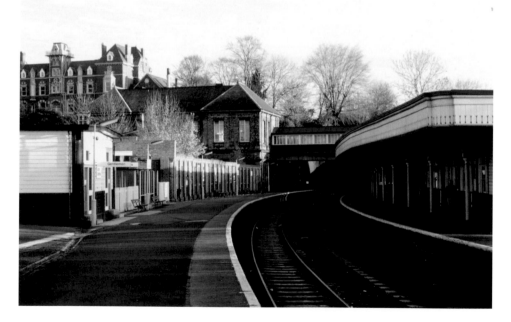

Sutton Coldfield Station
Sutton was originally at the end of the branch from Aston, and that terminus was on the far left of this image. The extension from Sutton to Lichfield involved the making of two new platforms on a curve and a new booking office. (Author's Collection)

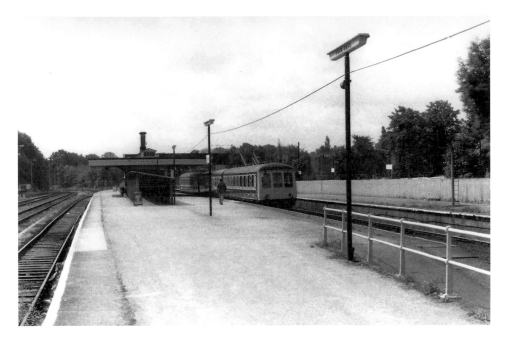

Four Oaks Station, London & North Western Railway
The extension from Sutton Coldfield to Lichfield was constructed by the contractor J. Evans. Stations were initially provided at Four Oaks, Blake Street and Shenstone. (Author's Collection)

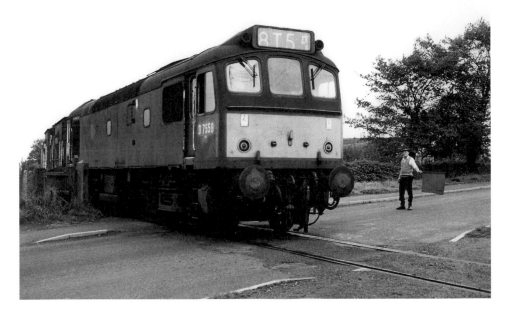

Level Crossing, Broad Lane, Bloxwich, London & North Western Railway
The mineral railway from Essington Wood Sidings (Cannock Branch) to the brickworks at Essington and towards Hollybank Colliery was in part maintained by the LNWR and their successors and in part by the colliery company. (Heartland Press Collection)

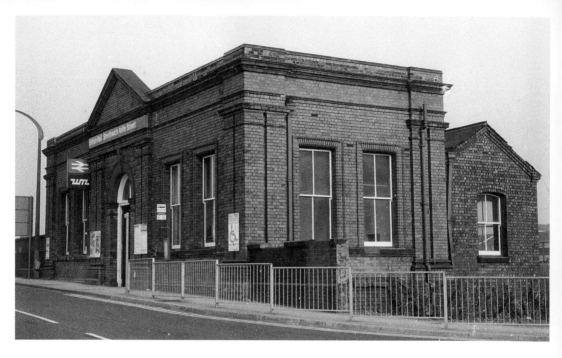

Smethwick Rolfe Street, London & North Western Railway

The imposing frontage to Rolfe Street replaced an earlier station structure when (in July 1890) the LNWR abolished two level crossings (Brasshouse Lane and Rolfe Street) at Smethwick. This created a higher level road that crossed the tracks once at Rolfe Street, and a second new road that joined Rolfe Street and curved around to Brasshouse Lane. The new booking office was completed by August 1890. (Author's Collection)

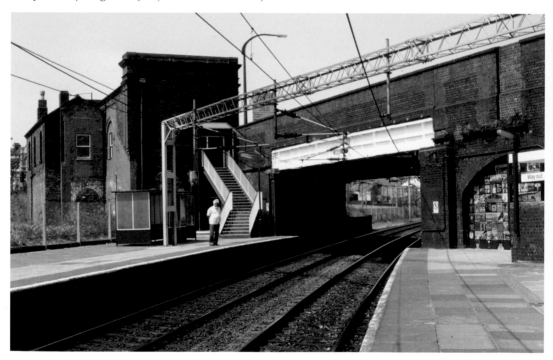

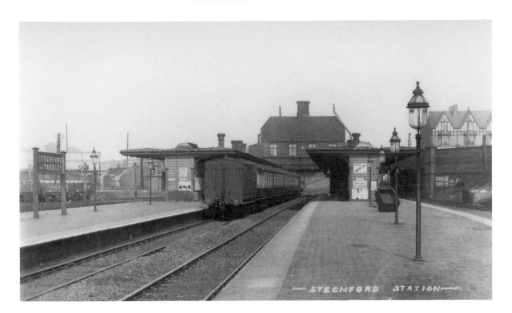

Stechford Station, London & North Western Railway
Stechford station was built for the London & Birmingham Railway and occupied a spot east of what was then a level crossing. With the making of the branch to Aston, a new station was constructed on the Birmingham side of the former crossing. This crossing was removed and the road raised to pass over the widened tracks. A booking office was placed on the bridge. (Heartland Press Collection)

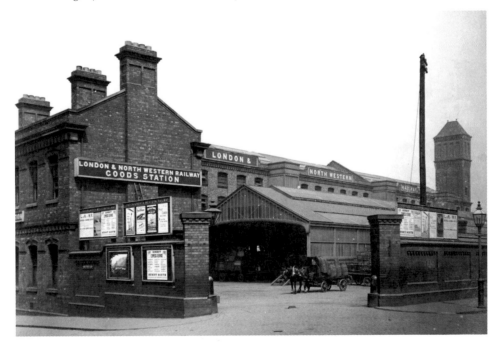

Aston Goods, Windsor Street, London & North Western Railway
The new warehouse at Windsor Street was brought into use during September 1901. (Heartland Press Collection)

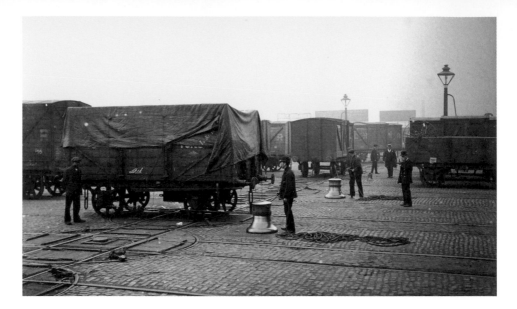

Curzon Street Goods Station, London & North Western Railway
The former Grand Junction and London & Birmingham passenger stations were converted into a single goods station by the LNWR following the diversion of passenger services into Birmingham New Street. A feature of the operation here was the hydraulically powered capstans used to move wagons within the confines of the depot. (Heartland Press Collection)

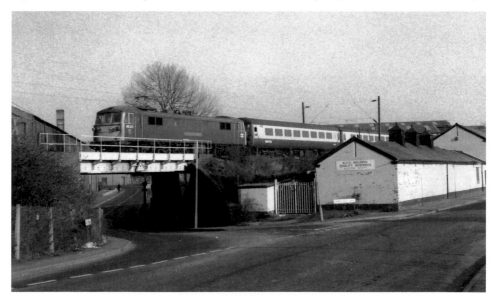

Deepfields (Coseley) Stables, London & North Western Railway
It appears that the stables at Deepfields were built for the canal and railway carrier Crowley, Hicklin & Co. around 1863. This property was inherited with the sale of their business to the LNWR. Deepfields goods station was located to the left, while the passenger station was on the embankment above the stables. From 1901 the passenger station was relocated further south, but the goods depot remained and handled traffic for local businesses, including Cannon, whose main premises were in Darkhouse Lane. (Author's Collection)

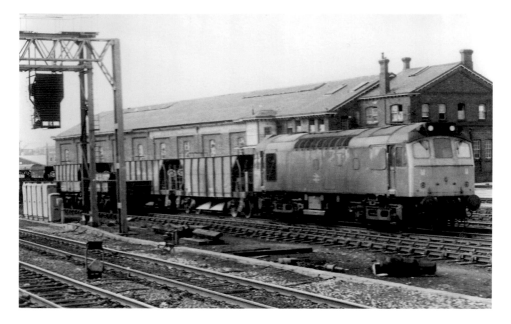

Walsall Goods, London & North Western Railway

Walsall station was reconstructed and the tracks widened during the early 1880s. The level crossing in Bridgeman Street was replaced by an underbridge when the pair of tracks through the former SSR station were doubled to four. Goods station accommodation was increased to suit the needs of the Midland Railway, LNWR and the GWR (who also had traffic for Walsall). (Author's Collection)

Duddeston Carriage Sheds, London & North Western Railway

The carriage sheds were completed during the period that Vauxhall station was moved and the railway north of Duddeston Mill Road quadrupled. They served to maintain and clean carriage stock for the LNWR, the LMS and British Railways. They were closed when coach stock maintenance was transferred to Oxley. (Author's Collection)

Duddeston Wagon Shops, London & North Western Railway

The wagon shops at Duddeston were established at the top end of the yard, which at one time served the Grand Junction Railway goods depot and locomotive sheds. They continued to repair and maintain wagons until British Rail transferred the work to Burton. The structure still stands although much of the roof has been removed. (Author's Collection)

Potters Lane, Wednesbury, London & North Western Railway

The LNWR signal box controlled signals, points and the gates at Potters Lane Crossing. (Author's Collection)

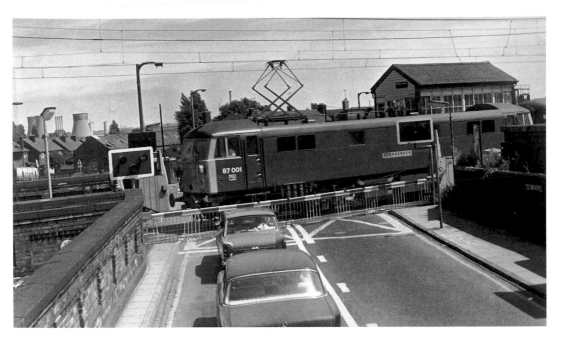

Level Crossing, Tipton, London & North Western Railway
The LNWR provided a level crossing and a subway for pedestrians (left) across Owen Street.
(Author's Collection)

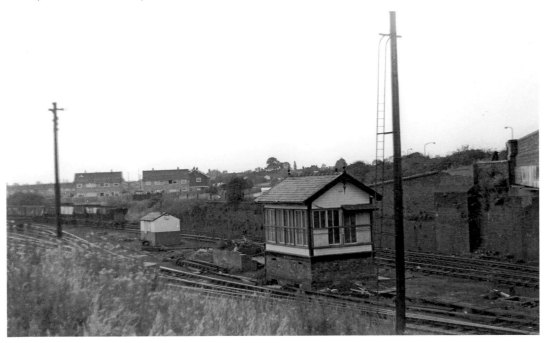

Norton Junction, London & North Western Railway
The Norton branch joined the South Staffordshire Railway at Norton Junction. It was made
as a freight-only line, built to serve mines at Norton Canes, and was opened during 1858.
(Author's Collection)

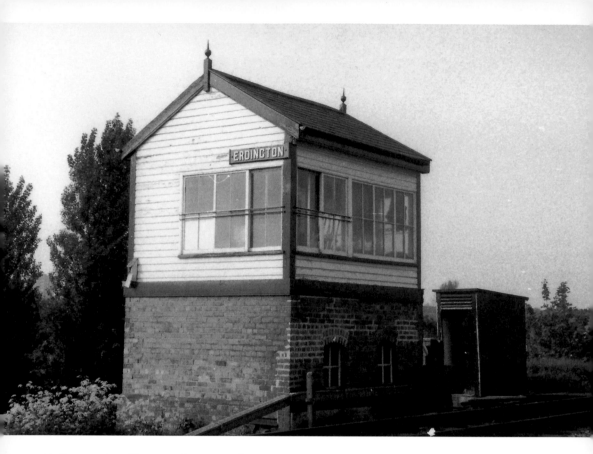

Erdington signal box, London & North Western Railway.

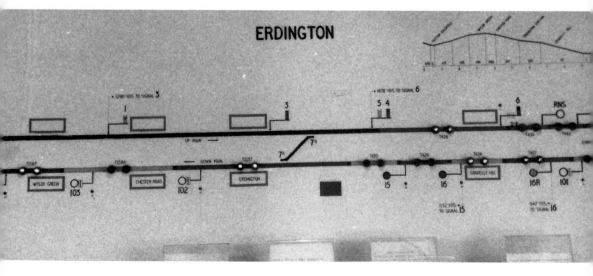

Erdington Signal Box Plan
Erdington box controlled the signals and points between Chester Road and Gravelley Hill. At one time there were also sidings for Erdington goods yard and Chester Road goods sidings. (Author's Collection)

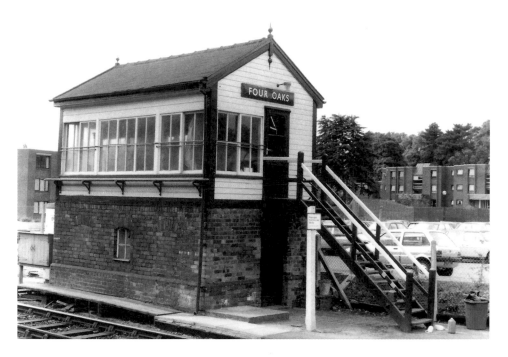

Four Oaks Signal Box, London & North Western Railway
The signal box was placed at the Birmingham end of the Down platform to Lichfield, and looked after the sidings and bay platform tracks. (Author's Collection)

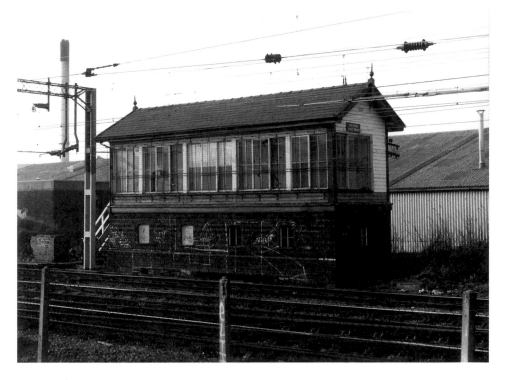

Stechford signal box, London & North Western Railway. (Author's Collection)

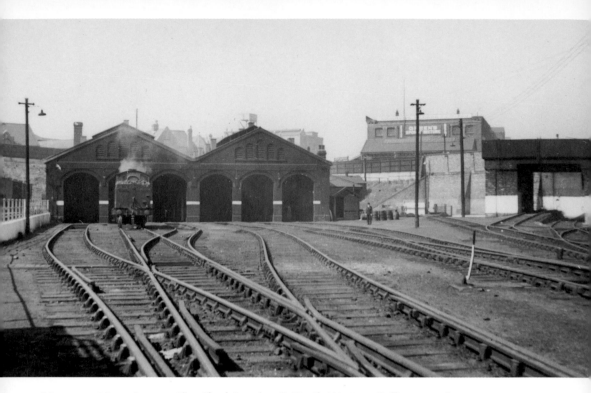

Monument Lane Locomotive Shed, London & North Western Railway, 1936
The LNWR passenger locomotive shed was placed beside the Birmingham, Wolverhampton & Stour Valley Railway, and comprised two shed buildings (a building of two bays with louvres above the six-track entrance). The second, longer shed was to the right of the above image and adjacent to the main line. (London & North Western Society)

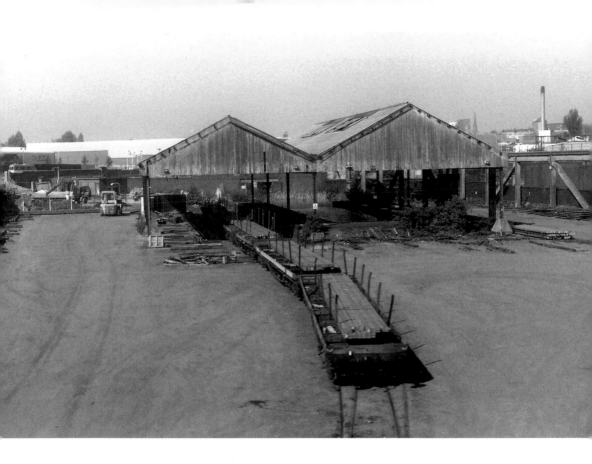

Monmore Green Interchange Basin, London & North Western Railway
The LNWR purchased the former Chillington Iron Company basin, and converted it into a railway interchange facility (1901–1902). Railway and canal interchange basins had been a feature of the railway network since the first railways, with early establishments made at Darlaston Green and Curzon Street. (Author's Collection)

3

Midland Railway Lines

The Midland Railway, within the West Midlands, incorporated into their system the:

Birmingham & Gloucester Railway
Birmingham & Derby Junction Railway
Wolverhampton & Walsall Railway

They increased their presence in Birmingham and the Black Country with the building of new lines from Castle Bromwich to Walsall and Brownhills and also were joint operators (with the GWR) of the railway from Longbridge to Halesowen.

The Midland routes were incorporated into the LMS from 1 January 1923 and into British Railways (London Midland Region) from 1 January 1948.

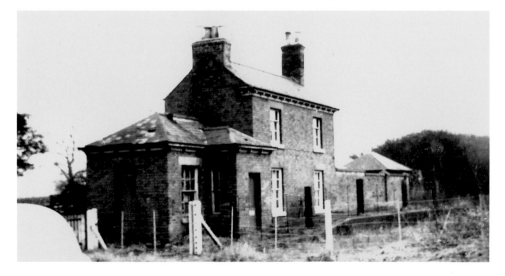

BDJR Coleshill Station
The section from Hampton to Whitacre was known as the Stonebridge Railway, and was made in this form after earlier schemes, including a junction at Stechford, had been abandoned. The only station on this section after Hampton was Coleshill, even though it was at a distance from that town. This station was renamed Maxstoke, and the station buildings and house remained after the railway had finally closed. (R. C. H. S. Ray Cook Collection)

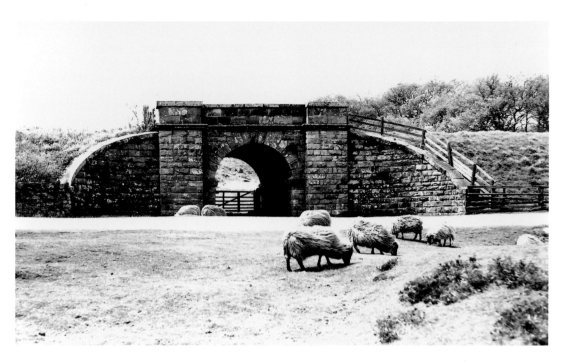

BDJR Stonebridge Railway, Stone Accommodation Bridge
There were various river crossings and bridges on the Stonebridge line, including this substantial structure, whose main function was to link two fields. (R. C. H. S. Ray Cook Collection)

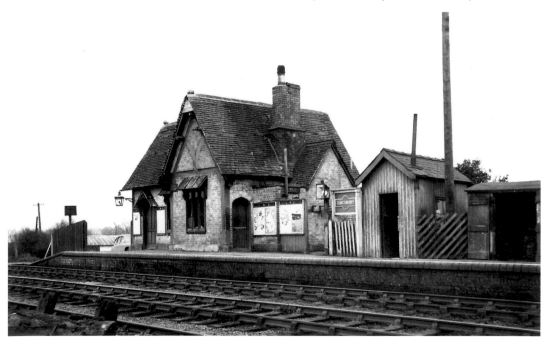

BDJR Kingsbury Station
North of Whitacre was Kingsbury station, complete with a station building that represents the BDJR period. (R. C. H. S. Ray Cook Collection)

Alvechurch Station House, Reddich Railway

Left: The Redditch Railway was opened in 1859, once the contractor George Furness had completed the work. The line was worked by the Midland Railway from the start and transferred to them from 1863. (Author's Collection)

Whitacre Station, Midland Railway

Below: Various schemes had been suggested for uniting Birmingham with Nuneaton and Leicester, but these did not become a reality until the Whitacre–Nuneaton line was completed for the Midland Railway. (R. C. H. S. Ray Cook Collection)

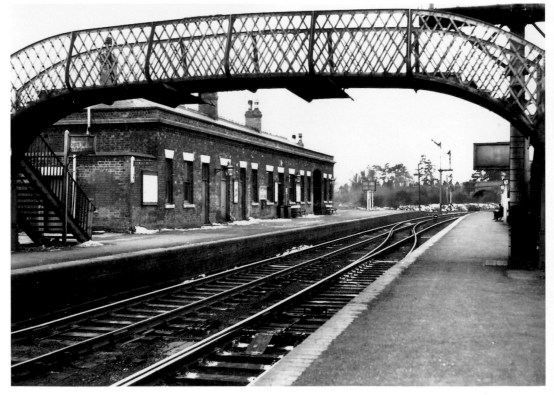

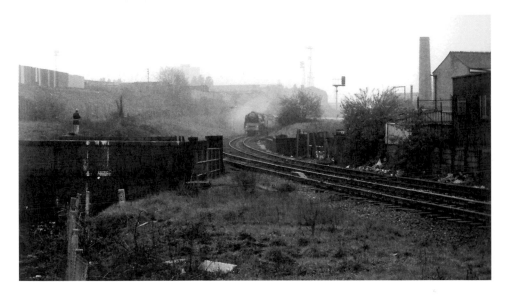

Brickyard Crossing

A short rail link was made between the Midland Railway lines to Lawley Street and that from Camp Hill to Exchange Sidings, creating an important bypass for freight traffic. The route involved few engineering features, but did require a bridge under the LNWR near Adderley Park and a level crossing for road access into a group of brickyards. (Author's Collection)

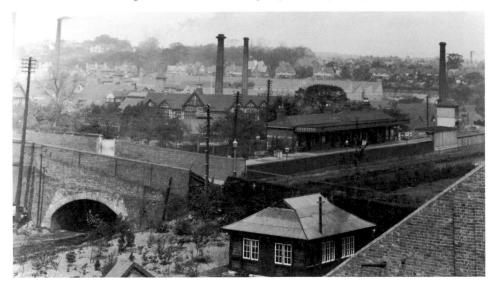

Bournville Station, Birmingham West Suburban Railway

The West Suburban Railway was constructed adjacent to the Worcester & Birmingham Canal. The station at Bournville, then named Stirchley Street, was placed alongside the single-track branch line from Kings Norton to Birmingham (Granville Street). The station had the name Bournville added to the title after Cadbury Brothers moved their factory from Bridge Street to here. The Midland Railway arranged for the reconstruction and widening of the route from Kings Norton through to new platforms at New Street, with corresponding reconstruction of stations along the route, including Bournville Street and Stirchley Street. (Heartland Press Collection)

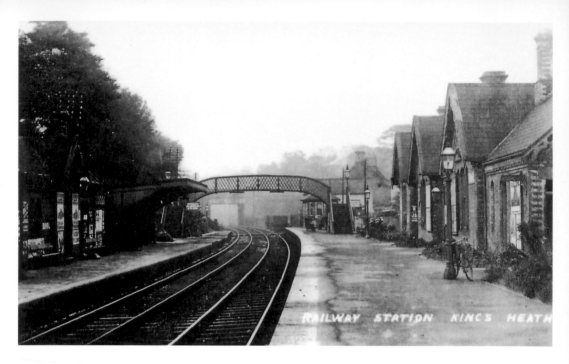

Kings Heath Station, Midland Railway
The former Birmingham & Gloucester station as seen looking towards Queens Bridge and the high street. The signal box was placed on the platform. (Heartland Press Collection)

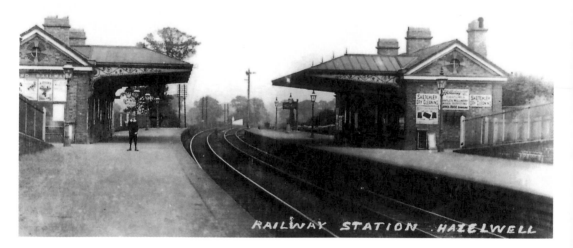

Hazelwell Station, Midland Railway
Hazelwell was built by the Midland Railway and opened in 1903. It served the spreading residential district for Birmingham folk, in what was then still part of Worcestershire. (Heartland Press Collection)

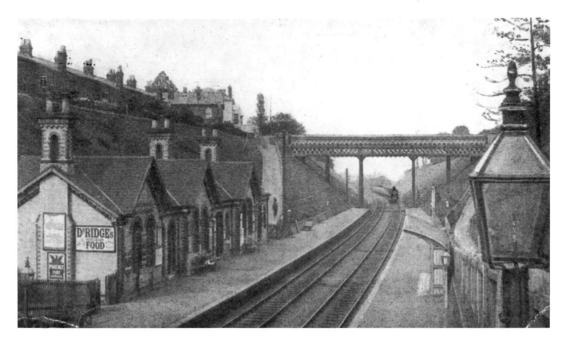

Moseley Station, Birmingham & Gloucester Railway

Moseley station was the second station on the Birmingham & Gloucester line to bear the name Moseley. The original one was renamed Kings Heath. This new Moseley station was opened in 1867 and was placed on a restricted access site north of Moseley Tunnel. Woodbridge Road crossed the line by bridge, as seen in this picture. (Heartland Press Collection)

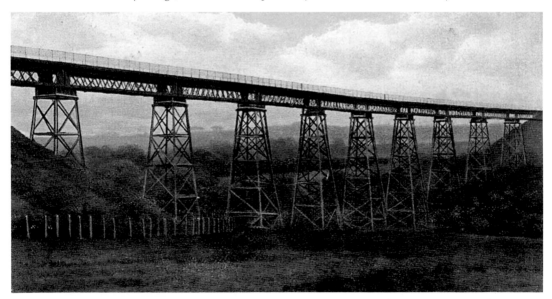

Dowery Dell Viaduct, Halesowen Railway

The metal viaduct, which spanned the valley of the River Stour, may be considered a lost railway wonder of the West Midlands. The only locomotives that could travel over this structure were those with a restricted axle loading, and it ceased to have any use once the Halesowen–Northfield workmen's specials stopped running (1960). (Heartland Press Collection, courtesy Michael Trowman)

Birmingham New Street, Midland Railway
With the reconstruction of the West Suburban Railway, a new Midland route into Birmingham New Street was created. A set of five platforms was added to the station complex, separated from the original LNWR station by Queens Drive. The new platforms were covered by an overall roof, which remained until the station was reconstructed, 1964–1967. (M. Mensing Collection)

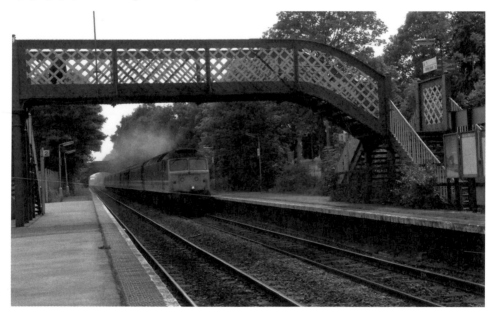

Midland Railway Barnt Green
Barnt Green in Midland Railway times had staggered platforms alongside the main line to Bristol. These platforms were altered during the widening scheme, financed by the London, Midland & Scottish Railway, that removed Crofton Tunnel. (Author's Collection)

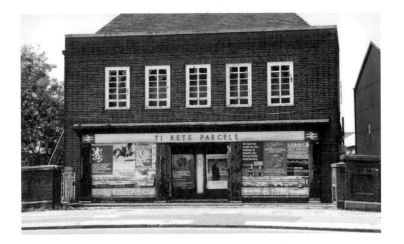

Longbridge Booking Office

The platforms at Longbridge were built to serve the First World War development of the adjacent munitions factory. After the war Herbert Austin used these premises as part of the expansion of his car factory. Built on the bridge that spanned the railway to Rubery and Halesowen, the booking office provided a general parcel and ticket sales service even if no scheduled passenger trains called at the platforms, and only workmen's trains ever stopped there. With the institution of the Cross City line services, Longbridge booking office was closed and ticket sales transferred to the new Longbridge station. (Author's Collection)

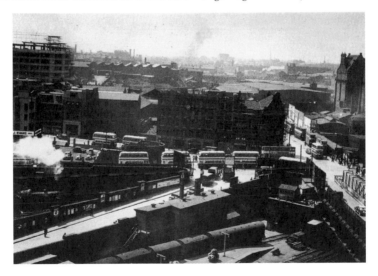

Birmingham New Street, 1949

The Midland Railway arranged for the construction of a new station beside the existing LNWR station, and their platforms were brought into use during February 1885, separated from the LNWR platforms by Queens Drive. Birmingham New Street became a joint station between the London & North Western Railway and the Midland Railway from April 1897 and retained this status until 1 January 1923, when the LMS took over both companies. The LMS, in turn, handed over the station to British Railways from 1 January 1948. In this view, the west (north) end of the station is seen, complete with a number of Birmingham Corporation buses and trams in Navigation Street, Hill Street and John Bright Street. In the distance (right) also visible is the former Midland Railway and LMS Central goods station. (Heartland Press Collection)

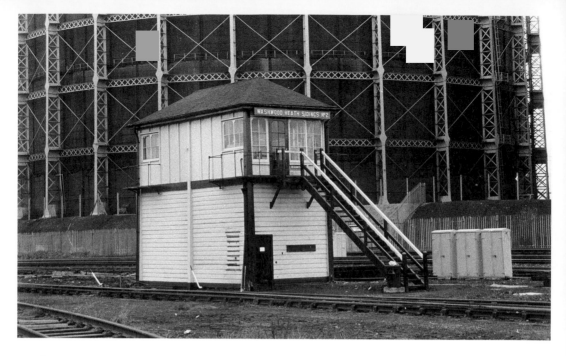

Washwood Heath No. 2 Box, Midland Railway
Washwood Heath sidings were established by the Midland Railway to handle freight traffic destined for Birmingham industries, including the extensive requirement for gas coals for the Corporation gas works. (Author's Collection)

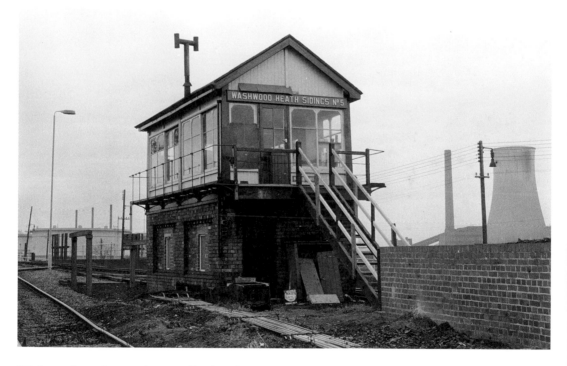

Washwood Heath No. 5 box, Midland Railway. (Author's Collection)

BDJR Locomotive Shed at Hampton-in-Arden
The Birmingham & Derby Junction Railway joined the London & Birmingham Railway at Hampton-in-Arden. It was here that they also established a locomotive shed. (R. C. H. S. Ray Cook Collection)

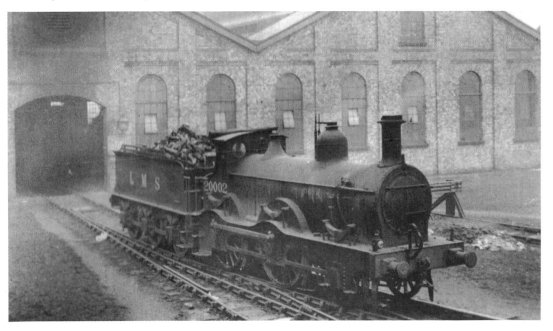

Midland Railway Locomotive Shed at Bourneville
The Midland Railway preferred to build round houses for its locomotive fleet. Sheds like this were provided at Landor Street (Birmingham) and Saltley. The shed at Pleck, Walsall, was a straight shed, however. (Heartland Press Collection)

4

Great Western Railway Lines

The Great Western Railway lines in this area came about through acquisition and merger. The first routes to reach and pass through Birmingham were the Birmingham & Oxford Junction Railway and Birmingham, Wolverhampton & Dudley Railway, which were mixed gauge lines (standard and broad gauge) and constructed after acquisition by the GWR. A separate railway was the Oxford, Worcester & Wolverhampton, which passed through Stourbridge, Dudley and Tipton to Wolverhampton, where it had a joint station with the GWR (BW&D). The Stourbridge Railway to Cradley was an independent venture absorbed by the OWWR. The OWWR became the West Midlands Railway and in this form merged with the GWR in 1863, adding mileage to the lines owned by the GWR in this region.

The GWR built new railways that joined with their existing network (Handsworth–Cradley, Swan Village–Great Bridge, Netherton–Old Hill and Old Hill–Halesowen). They also later widened and improved their main line between Handsworth and Olton, then Olton and Lapworth. Many of their stations were made to a standard design. Another major project was the construction of the North Warwickshire Railway, which provided a direct route, opened in 1908, to Stratford-upon-Avon from Tyseley.

The GWR retained their separate identity at the 1921–23 grouping of railways, and became British Railways (Western Region) from 1 January 1948.

Wolverhampton Low-Level Station, OWWR & BWD Joint Station

At the west end of the low-level station, the Wednesfield Road spanned many tracks by an iron bridge. Wolverhampton was the northern limit of the broad gauge. In this view, taken before the broad gauge track was removed, the arrangement of the mixed gauge tracks can be seen. Looking at each set of three mixed gauge rails, the rail on the right was used by both standard and broad gauge stock, while the first on the left was also for the use of the standard gauge stock, and the far left rail was for broad gauge stock to run along. (Heartland Press Collection)

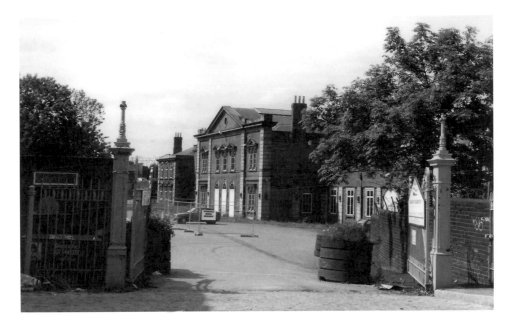

Wolverhampton Low-Level Station, Birmingham, Wolverhampton & Dudley Railway
The imposing facade of Wolverhampton station was constructed as a joint station for the Birmingham, Wolverhampton & Dudley Railway, the Oxford, Worcester & Wolverhampton Railway, and the Shrewsbury & Birmingham Railway. (Author's Collection)

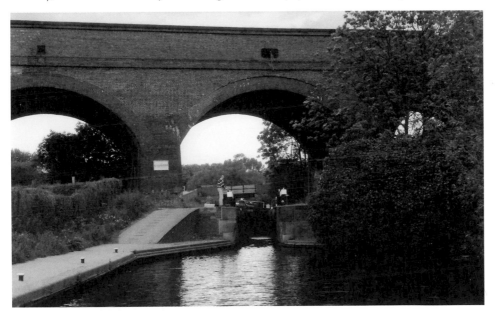

Parkhead Viaduct, Dudley, GWR
When the Oxford, Worcester & Wolverhampton Railway was built through the West Midlands to Wolverhampton, there were three timber viaducts – at Hoo Mill (Kidderminster), Stamber Mill (Stourbridge) and Parkhead (Dudley) – built to the designs of I. K. Brunel. By 1880 all three structures required rebuilding, and the GWR decided to replace all three with brick. (Author's Collection)

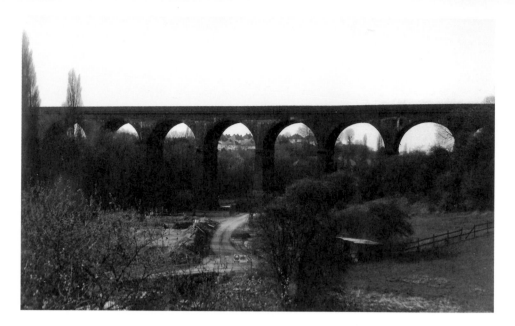

Stambermill Viaduct, Stourbridge, GWR
The Oxford, Worcester & Wolverhampton Railway spanned the River Stour by a tall wooden viaduct. This viaduct was reconstructed in brick by the GWR, but parts of the original pier supports remain. (Author's Collection)

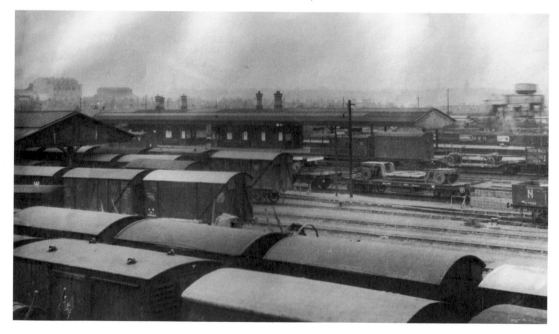

Hockley Station, GWR
The original BWD station at Hockley was replaced by a modern GWR station during the upgrade and widening of the railway between Snow Hill and Handsworth. It was demolished with the closure of the Snow Hill line (1972). With the opening of the Jewellery Quarter line, a new station was built further south, with access to Vyse Street. (Author's Collection)

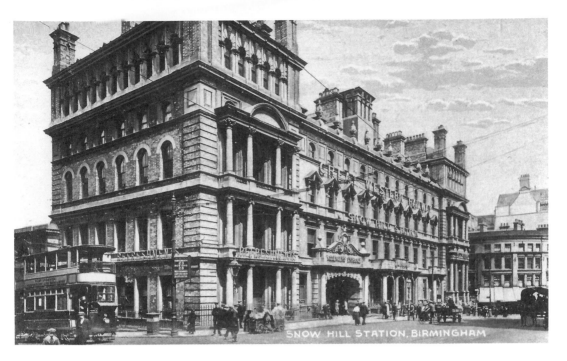

Snow Hill Station, Livery Street, Birmingham

The Great Western were first responsible for the joint Birmingham, Wolverhampton & Dudley and Birmingham & Oxford Junction station. This station was rebuilt for the GWR during 1871 and then again between 1909 and 1911. The final enlarged structure had an overall roof that extended from Livery Street to Snow Hill and from Colmore Row to Great Charles Street. Fronting Colmore Row was an impressive railway-owned hotel. (Heartland Press Collection)

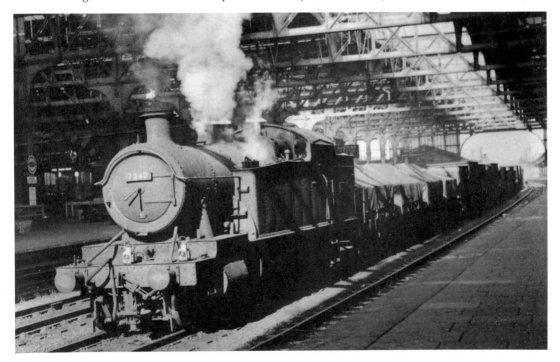

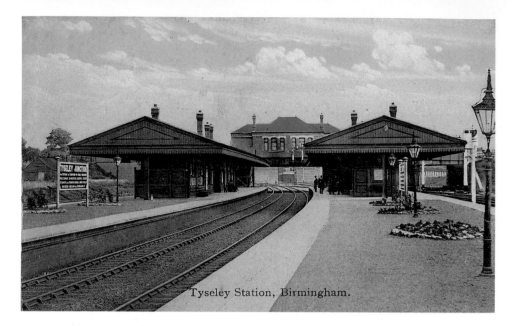

Tyseley Station, Birmingham.

Tyseley Station, GWR

Tyseley station was opened on the Birmingham & Oxford Junction route, north of the new junction that was made for the North Warwickshire Railway. In this postcard view the station is named as Tyseley Junction, although later this was shortened to Tyseley. (R. C. H. S. Spence Collection)

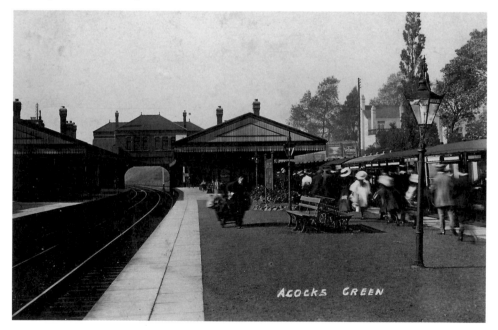

ACOCKS GREEN

Acocks Green Station, GWR

The GWR arranged for the widening between Bordesley and Olton that created four tracks through Small Heath, Tyseley and Acocks Green. Both Small Heath and Acocks Green stations were reconstructed with additional platforms. (R. C. H. S. Spence Collection)

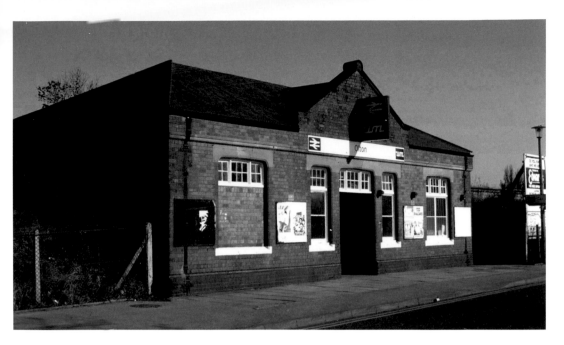

Olton Station, Booking Office, GWR
Olton was the limit of the widening between Olton and Bordesley that led to the reconstruction of Olton, Acocks Green and Small Heath stations and the relocation of Bordesley station on a new site north of Coventry Road. (Author's Collection)

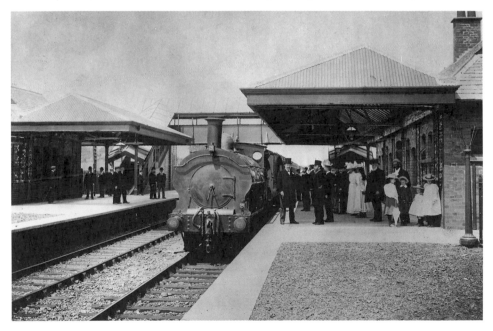

Opening of Widney Manor, Great Western Railway, 1899
Widney Manor was built later than other stations on the line, between Birmingham Snow Hill and Leamington. The station was built at the request of the lord of the manor. (R. C. H. S. Spence Collection)

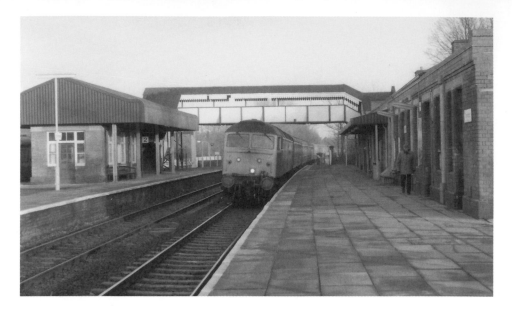

Knowle & Dorridge Station, Great Western Railway
Knowle was originally a station on the mixed gauge line (GWR Birmingham & Oxford Junction Railway). Cleveland Bridge & Engineering had the contract to widen the Great Western Railway between Olton and Lapworth. The work involved the addition of two additional pairs of tracks, and station reconstruction at Solihull, Widney Manor, Knowle and Lapworth. At Knowle there were extensive alterations to the original booking office side (right). (Author's Collection)

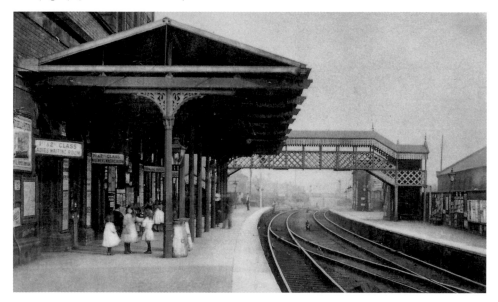

West Bromwich Station, Birmingham, Wolverhampton & Dudley Railway
The railway from Birmingham to Wolverhampton was made to mixed gauge (that is standard and broad gauge). While the broad gauge line was removed in 1869, the distance between the platform edges could not be changed, hence the width between the two running tracks. (Sandwell Libraries)

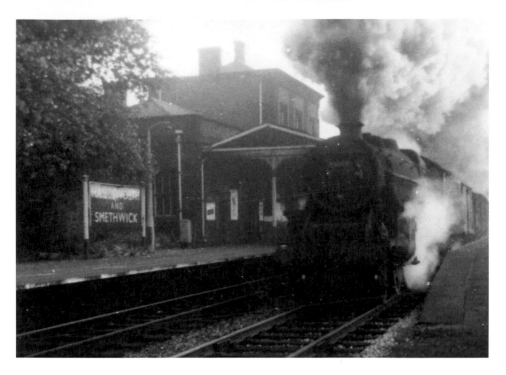

Handsworth & Smethwick Station, Birmingham, Wolverhampton & Dudley Railway, 1966
The station buildings at Handsworth, West Bromwich and Bilston were constructed to a similar design by builders Branson & Gwyther of Birmingham. Handsworth station was, however, enlarged by the GWR, with the addition of an extra pair of tracks. (Author's Collection)

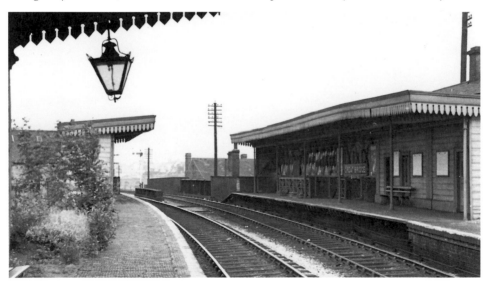

Great Bridge Station, Great Western Railway
It had been the intention of the Birmingham, Wolverhampton & Dudley Railway to build a branch to Dudley. The branch was finally made by the GWR, but only from Swan Village to Great Bridge. The GWR had running powers over the South Staffordshire Railway to Dudley. (Author's Collection)

Swan Village Junction, Great Western Railway
The route to Wolverhampton is on the right, while the line to Great Bridge curves off to the left. (Heartland Press Collection)

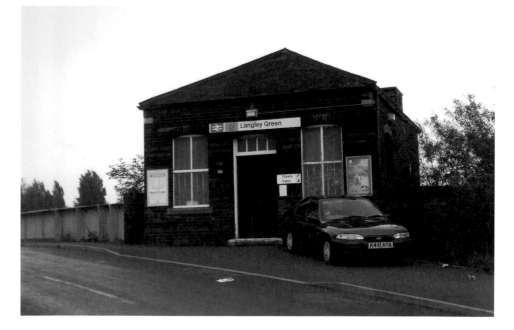

Langley Green Station, Stourbridge Extension Railway
The booking office at Langley Green was a brick structure built on two levels: platform and street. The bridge on the left spanned the Oldbury Railway, which joined the Extension line at Langley and formed a branch line to Oldbury (GWR) station and the interchange basin with the Birmingham Canal. (Author's Collection)

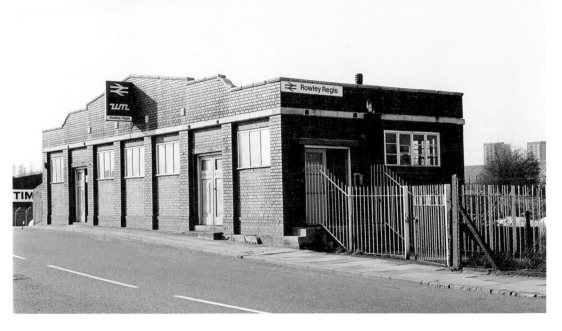

Rowley Regis Station
At Rowley Regis the main station buildings were placed on the platform, but later the Great Western Railway provided a new booking office on the bridge over the running lines. (Author's Collection)

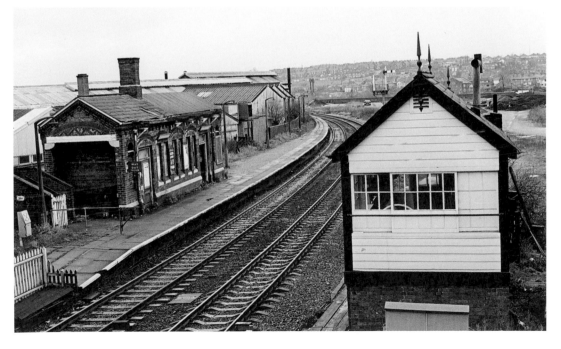

Cradley East Signal Box and Platform Buildings, Stourbridge Railway
Cradley East signal box once controlled the goods yard that had sidings access to the south end of the Pensnett Railway. (Author's Collection)

Stourbridge Junction, GWR
The Great Western Railway relocated the site of the junction station in 1901, when the branch to the town station was altered to run into the left-hand platform. (Author's Collection)

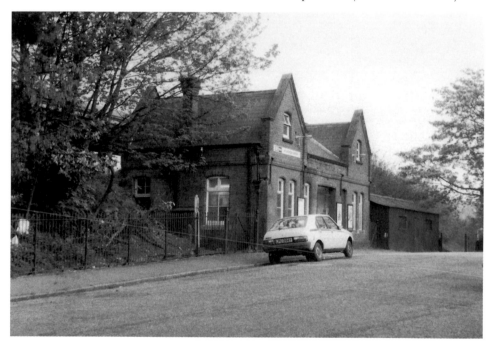

Stourbridge Junction Booking Offices, GWR
The Great Western Railway arranged for the construction of the booking office and drive. Access to the platform was made through the subway and steps to the platforms. (Author's Collection)

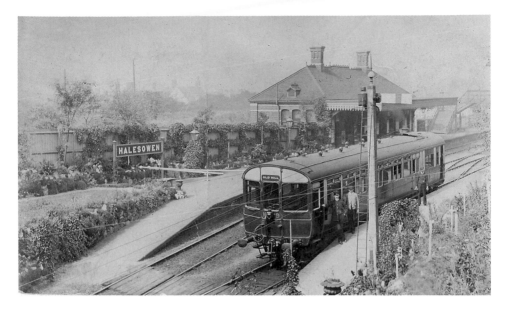

Halesowen Station, Great Western Railway
Halesowen was at the end of the branch railway from Old Hill. H. Lovatt was the contractor for this branch, which had a short tunnel at Old Hill as well as a long embankment section towards Halesowen. This was also a joint station for Midland Railway services from Longbridge. A GWR steam railcar is seen in this view. This type of traction was common on certain branch lines, like Halesowen and Oldbury. The principal traffic was freight, which included coal from Coombeswood Colliery and Hawne Railway interchange basin. (R. C. H. S. Spence Collection)

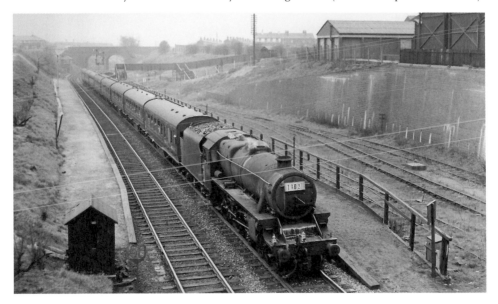

The Hawthorns Halt, Great Western Railway
Football matches at the nearby West Bromwich ground led eventually to the building of platforms on the Birmingham, Wolverhampton & Dudley Railway north of the junction with the line to Stourbridge. The basic constructed platforms adjoined the private sidings that served Jubilee Colliery. (M. Mensing Collection)

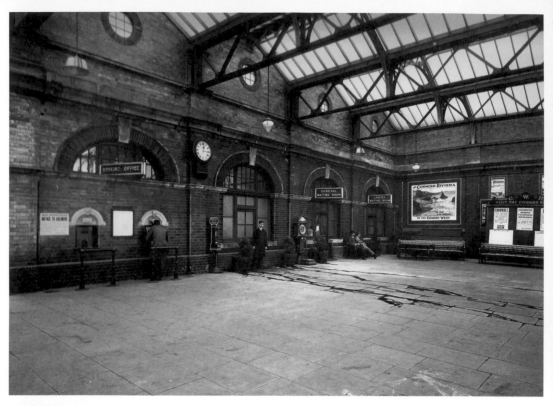

Moor Street Station Booking Office, 1915
The passenger station at Moor Street was opened in 1909, but had a temporary booking office while the passenger concourse was constructed. This work, it appears, went on for a lengthy period. Some histories quote the completion of passenger facilities as similar to that of the adjacent goods depot, in 1914, although this GWR official photograph of May 1915 might prove that the work went on longer, and official GWR plans of the passenger station were not produced until 1916. (Heartland Press Collection)

Left: Moor Street concourse. (Author's Collection)

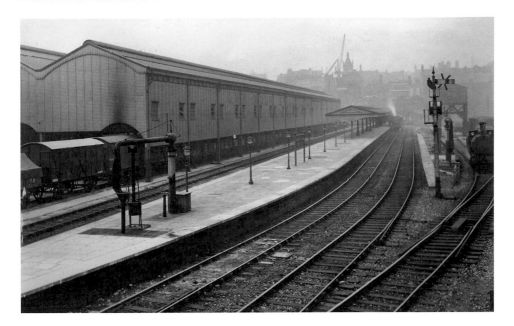

Moor Street Goods Station, Birmingham
The Great Western Railway built a commuter station at Moor Street, which was first opened for passenger traffic during 1909, albeit in an incomplete and basic form. (Heartland Press Collection)

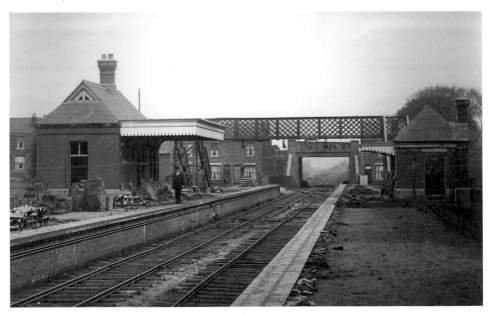

Tettenhall Station, GWR, 1916
The railway extension from Kingswinsford to Oxley planned to provide a passenger service to the western suburbs of Wolverhampton, including Tettenhall. Construction work was delayed because of the war, but contractors' locomotives did bring the wounded by train to Tettenhall during this period. Passenger trains commenced in 1925 after the GWR finished the outstanding construction tasks. (Heartland Press Collection)

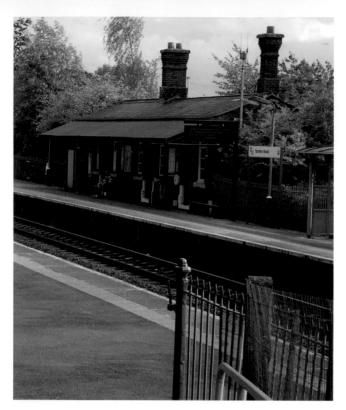

Yardley Wood Station, North Warwickshire Railway, GWR
The North Warwickshire Railway has station buildings built to the standard design adopted by the GWR across their system, made with brick and stone from specific suppliers. (Author's Collection)

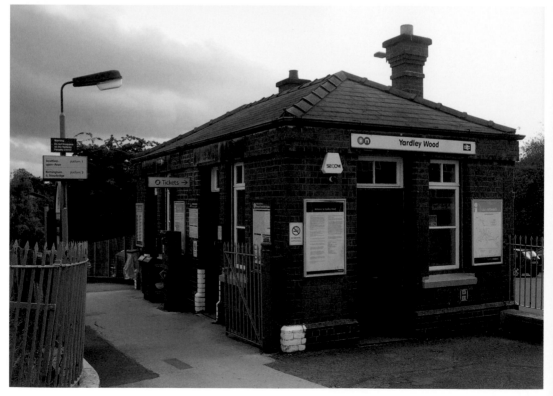

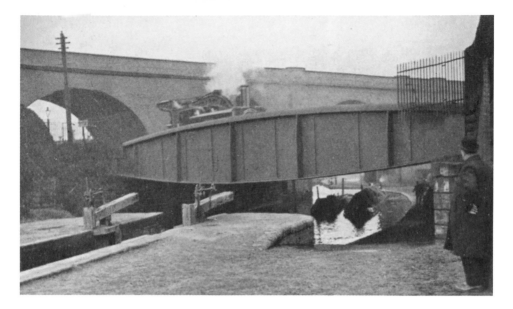

Wolverhampton Junction Railway Crossing of Birmingham Canal

There was a concentration of transport routes at this spot. Two narrowboats are seen heading for the eleventh lock on the Wolverhampton Flight of the Birmingham Canal, while the GWR Stafford Road works crane tank stands on the railway bridge that spans this waterway. The iron bridge is itself of an unusual design and was later replaced. It carried the tracks to the shed and works, and there was a separate bridge for the railway to Shrewsbury (Wolverhampton Junction Railway) beyond it. Towering above all is the high viaduct that carried the LNWR Stour Valley line to Bushbury. (Author's Collection)

Warwick Road Bridge, Olton, GWR

This style of steel bridge was made to carry four tracks over Warwick Road on the railway-widening extension made between Olton and Lapworth, and was carried out by the Cleveland Bridge & Engineering Co. A first-generation diesel unit is seen approaching this bridge in British Rail days. (Author's Collection)

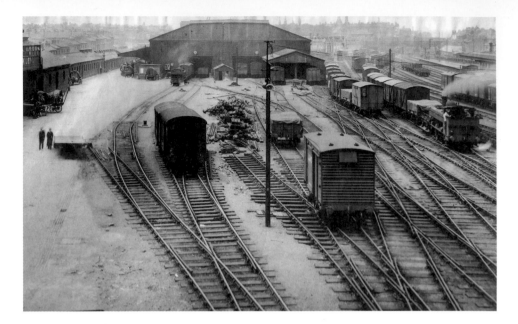

Hockley Goods Depot (Goods Inward Shed), 1939
Hockley became the main GWR goods depot in Birmingham, dealing with both goods and parcels services. The site occupied an extensive strip of land alongside the railway, and at the north end had access via a wagon lift to the Hockley canal and railway interchange basin. There were two large sheds: Goods (Inwards) and Goods (Outwards). (Heartland Press Collection)

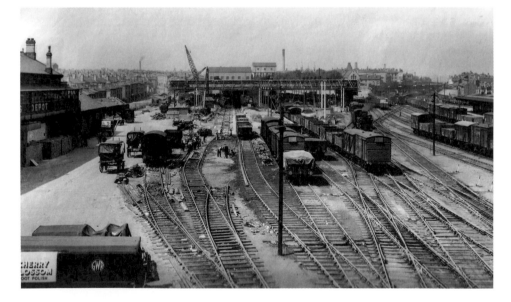

Hockley New Goods Sheds, 1940
Hockley Inwards and Outwards goods sheds were replaced by a large, new single shed that spanned Icknield Street. This work was conducted between 1938 and 1942, and created a modern goods depot for the GWR in Birmingham. It was a depot that had a relatively short future, being closed after the main-line services ceased (1967/8), when its principal traffic, parcels, transferred to the new Curzon Street Depot. (Heartland Press Collection)

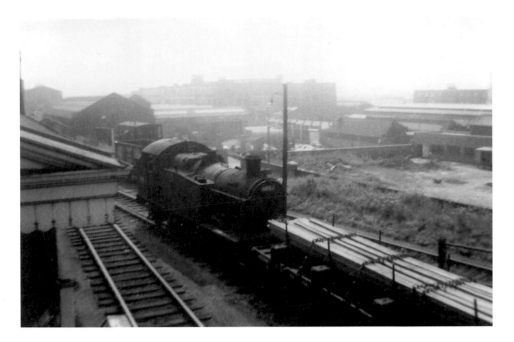

Handsworth Goods, Great Western Railway

The GWR embarked on an extensive track-widening program throughout Birmingham and its outer suburbs. Handsworth & Smethwick station was reconstructed with another pair of tracks and two additional platforms. On the west side, sidings were also provided for a goods depot adjacent to Downing Street. (Author's Collection)

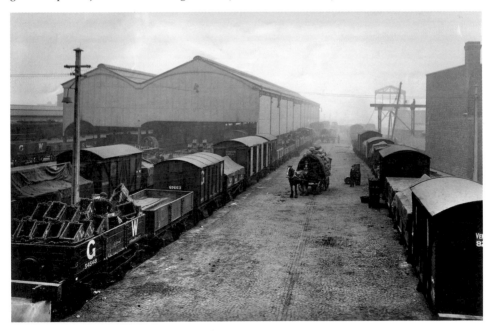

Moor Street Goods Station, Upper Level

Moor Street goods station was constructed on two levels, and completed during 1914. The lower level was reached by wagon lifts. (Heartland Press Collection)

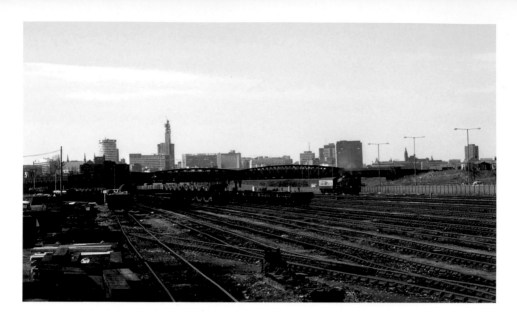

Small Heath Sidings

The Great Western Railway enlarged the freight sidings at Small Heath from time to time. Part had been used as a locomotive depot (Bordesley Junction), but this was removed when Tyseley opened. They became a major destination for freight services and for trip working to other GWR goods depots as well as the exchange traffic on to the Midland and LNWR. (Author's Collection)

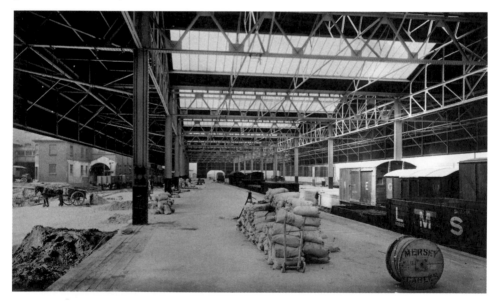

Herbert Street Goods Depot, Wolverhampton, Great Western Railway

Herbert Street was a modern goods depot built on the site of Victoria Basin, the Shrewsbury & Birmingham Railway canal and rail interchange basin. It was retained by British Railways, but closed at the time of the reorganisation of freight and parcel services in this area. The buildings then served a builders' supply business until 2012, when it was destroyed by fire. (Author's Collection)

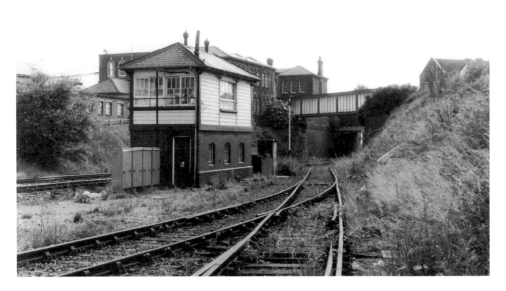

Round Oak Signal Box, Brierley Hill, GWR
The OWWR passed though the Black Country to reach Wolverhampton and make various junctions with other railways. At Round Oak the route crossed the already established Pensnett Railway (owned by the Earl of Dudley's trustees) on the level. (Author's Collection)

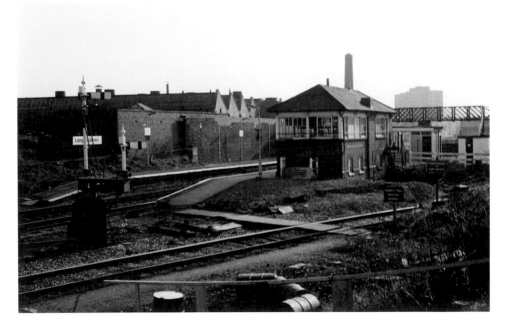

Langley Green Station, Stourbridge Extension Railway
The signal box was placed on the platform, like it was at Old Hill. In the foreground the lines to Oldbury Interchange station and the Albright & Wilson phosphorus works diverged. (Author's Collection)

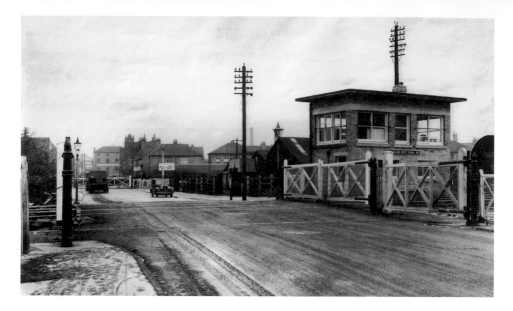

Swan Lane Level Crossings, GWR

Swan Lane was crossed by three sets of railway tracks. That in the foreground formed the main BWD line between Birmingham and Wolverhampton, while a second (with the gates across the road) was the line from Swan Village to Great Bridge. A third (out of sight) was an un-gated crossing for the gasworks. A modern GWR signal box served as the main line crossing box. (Author's Collection)

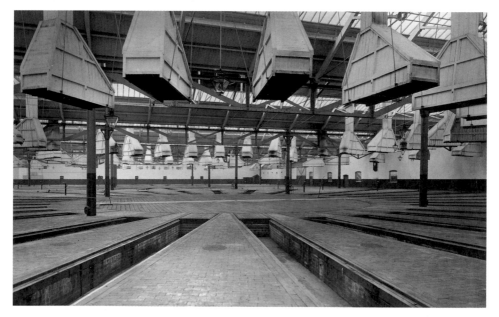

Tyseley Locomotive Sheds, GWR, Interior

The Great Western Railway sheds, in Birmingham, were located at Bordesley. Following the extensive widening program and building of new lines, a new depot was made at Tyseley. In this view the two roundhouses are shown at the time of construction. Each turntable was made to a diameter of 65 feet with twenty-eight roads radiating from each. (Author's Collection)

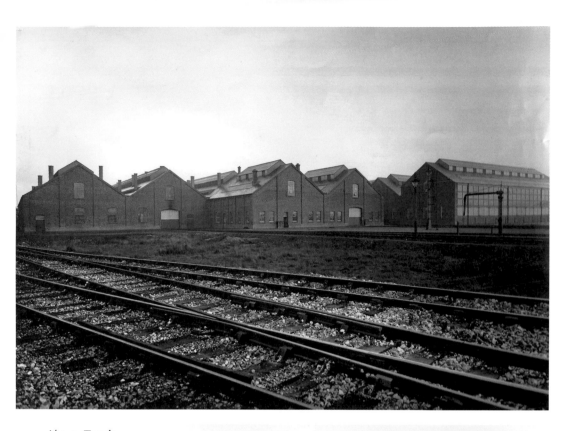

Above: **Tyseley Locomotive Sheds, Exterior**
The sheds as built are seen in this view. On the right was a workshop and lifting shop for carrying out locomotive repairs. (Author's Collection)

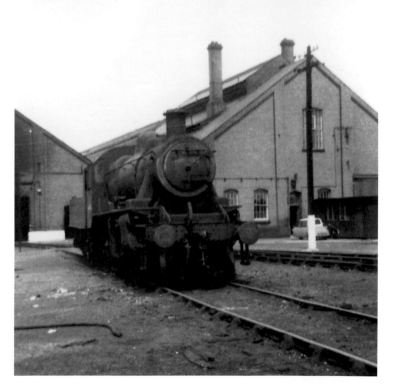

Right: **Oxley Shed, Wolverhampton, 1967**
Oxley locomotive shed was completed in 1907 for the GWR and was primarily a depot for freight locomotives. (Author's Collection)

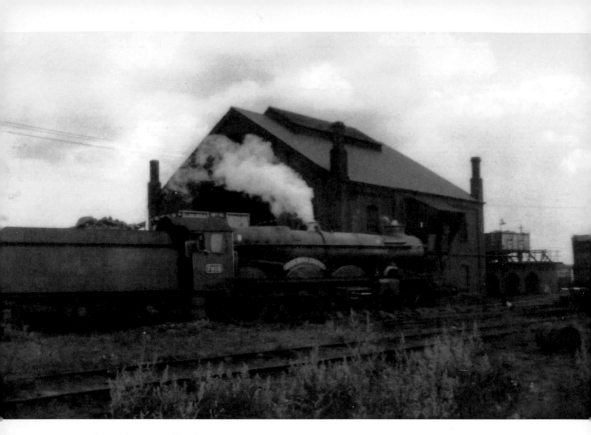

GWR Coaling Plant, Stafford Road
The GWR/SBR running shed at Stafford Road was placed on a restricted site adjacent to the locomotive works. As the shed was enlarged, the location of the coaling plant moved to a new site alongside the Wolverhampton Junction Railway and beside the canal; it was constructed by 1914. (Heartland Press Collection)

5

British Railways

British Railways was responsible for West Midland railways between 1948 and 1997. During their tenure they were responsible for railway closures, conversion of some routes into freight-only lines and also the building of new stations and reopening of certain routes.

The former LMS routes became part of the London Midland Region, while the GWR routes passed to the Western Region until 1964, when the remaining former GWR routes in this part were transferred to the LM Region. BR (LM) then had control of all Birmingham and Black Country passenger railways, while several other lines were retained exclusively for freight traffic and became important links in the national freight network, even if this was a dwindling traffic. Road hauliers took an increasing amount of this trade as British industry declined.

Policies changed in the 1980s as local and cross-country services were rebranded; out of this was created Regional Railways in the early 1990s, while the fast trains that linked principal towns and cities came under the InterCity banner.

The speeding up of long-distance services was a long-term British Railways policy. This first happened with diesels replacing steam traction and then electrification of the West Coast Main Line as well as the routes Rugby–Coventry–Birmingham–Wolverhampton–Stafford and Birmingham/Stechford–Aston–Bushbury/Walsall. This electrification was completed in 1967.

Ocker Hill Power Station, Wednesbury An early development in the days of British Railways was the completion of the railway sidings to the British Electricity Authority's Ocker Hill power station. Work for this had been started in 1945 and siding links arranged with the LMS, but before the station opened, the LMS had become part of British Railways. (Author's Collection)

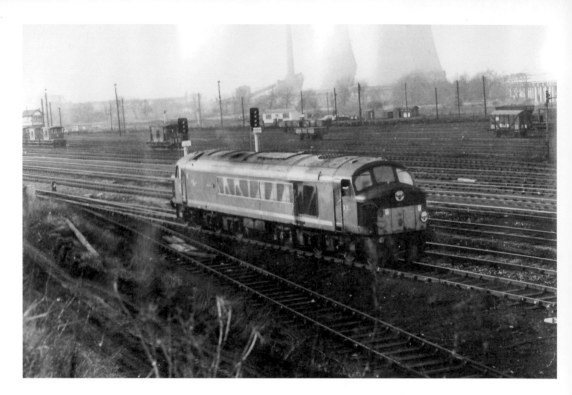

Washwood Heath Marshalling Yards

At Washwood Heath, the Midland Railway built extensive sidings, which adjoined the main line from Birmingham to Derby. They were the destination for a number of freight services and in particular, coal for the gasworks at Nechells and Saltley during their control. In BR times they were also the destination for Nechells power station. (Author's Collection)

NATIONAL COAL BOARD

Seller **EAST MIDLANDS DIVISION**

Place of Weighing Date of Despatch

6 Q BENTINCK 7 4 67 1967

Type of Fuel

A BLENDED 1.5IN SMALLS

TO

TAME & REA SDGS

WASHWOOD HEATH

M	U	2

Consignee
NECHELLS GEN. STATION

WAGON NUMBER	H	SALE WEIGHT OF FUEL
205104		14 .13 c
TARE 6 .9 c		

Date of Weighing 11 APR 1967

DATE OF WEIGHING

DATE OF DESPATCH

Seller and Place of Weighing APR 1967
NATIONAL COAL BOARD EAST MIDLANDS DIVISION
No. 4 Area **PLEASLEY Colliery**

A/c

To NECHELLS
 GAS WORKS

M	U	2

Consignee Birmingham Gas

Type of Fuel Nuts Ex Wsh.

WAGON NUMBER	H	SALE WEIGHT OF FUEL
201032		10 .16 c
TARE 6 .9 c		

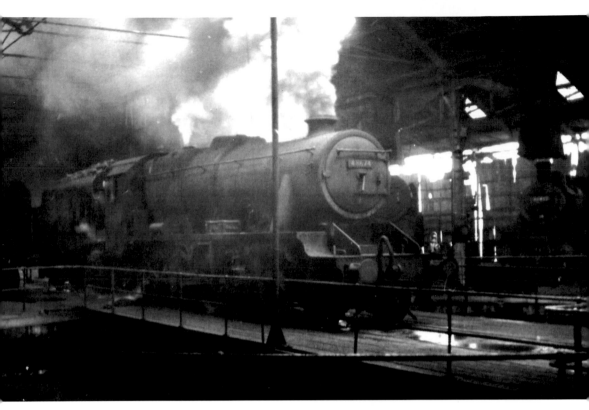

Above: *Tyseley Shed, 1966*
British Railways demolished half of
Tyseley locomotive shed in order to use
the space as a new diesel locomotive
maintenance depot. The one round house
that was retained was a running shed for
steam locomotives until 1966, although
locomotives continued to visit the new
adjacent depot for wheel turning through
to 1968. (John Oakes Collection)

Right: *Tyseley Depot*
British Railways built a new maintenance
depot at Tyseley for diesel locomotives,
and this depot has continued the
maintenance role though to the present
time. With railway privatisation, Tyseley
became the responsibility of Maintrain,
and by this time maintenance was
generally confined to multiple unit stock.
(Author's Collection)

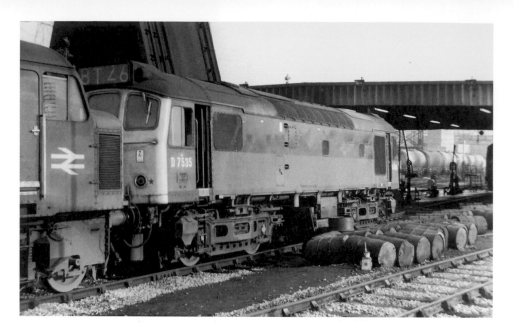

Saltley Depot
The Midland Railway built a locomotive depot facing Duddeston Mill Road beside the main line from Birmingham to Derby. When the steam shed was closed, British Railways built a stabling and fuelling point for diesel locomotives. The structure in the background is the concrete coaling plant, which was later demolished. (Author's Collection)

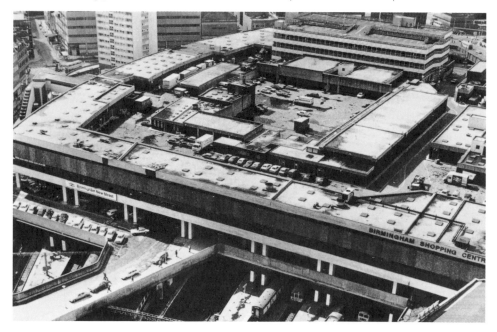

Birmingham New Street, British Rail
Looking down from a vantage point on the rotunda provides a view of the station that is rarely seen, and one that will alter with the reconstruction of the station. (Heartland Press Collection)

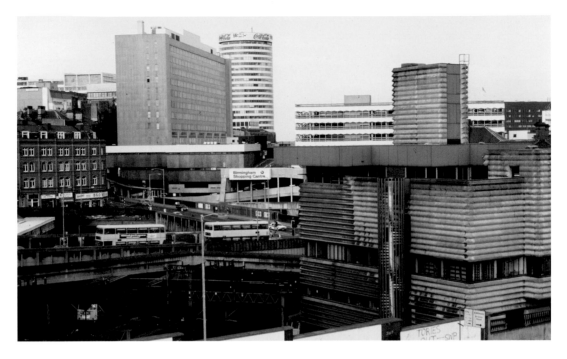

Birmingham New Street station and signal box, British Rail. (Author's Collection)

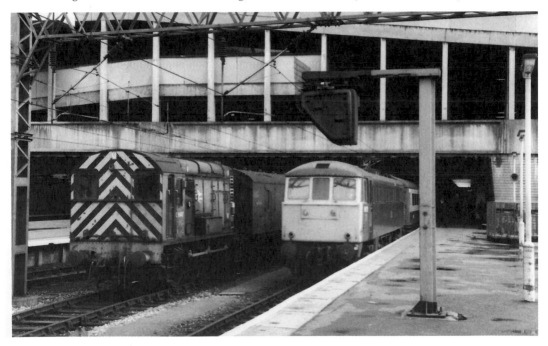

Birmingham New Street, British Rail

New Street was rebuilt during the British Railways electrification scheme. The rebuilt station reopened to traffic in 1967. The car park, pedestrian concourse and Pallasades shopping centre spanned the track and twelve platforms, creating a dark place for passengers. (Author's Collection)

Vauxhall Station, British Rail

The original Grand Junction station was located near the present site of the station, which was only open for a short period. A new Vauxhall station was built for the LNWR north of the road bridge, and remained there until the tracks were widened in 1890, at which time the platforms were moved south of the bridge. The booking office and platforms were severely damaged by bombing during the war, and were later rebuilt. In this view the wagon shops are seen on the left and the LNWR carriage shed is to the far right. (Author's Collection)

Curzon Street Parcels Depot

Curzon Street goods depot was rebuilt as a parcel concentration depot. A modern shed with a central main platform received parcels trains through the night and the day. (Author's Collection)

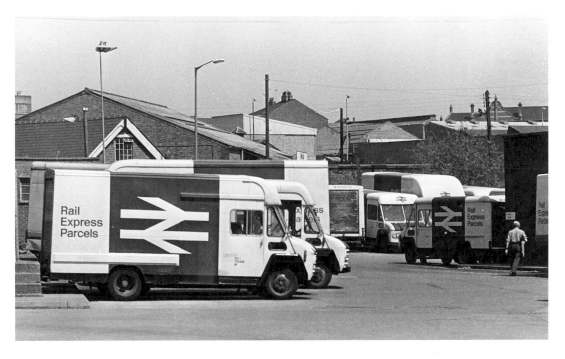

Parcel Vans, Curzon Street Parcels Depot Yard
National Carriers Ltd provided a fleet of road vehicles for parcel collection and delivery purposes.
(Author's Collection)

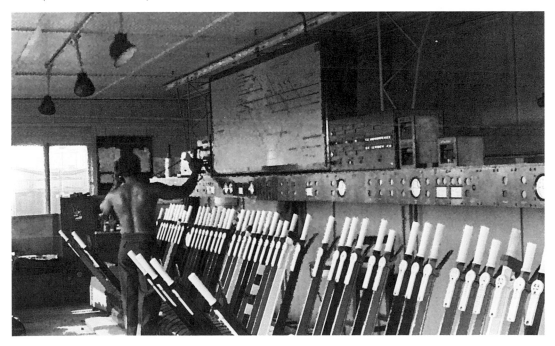

Curzon Street Signal Box
British Railways built a new signal box, with 100 levers, for the parcels depot. Pulling these was
a skill that the signalman had to master. (Author's Collection)

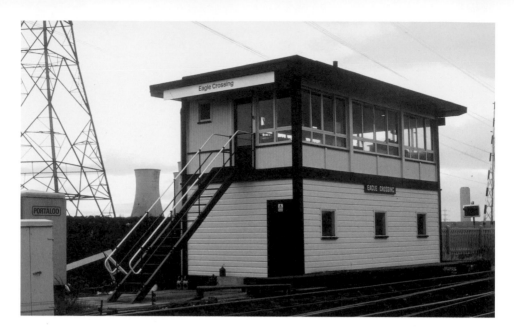

Eagle Crossing Signal Box
British Railways also built a new signal box at Eagle Crossing in the place of an earlier LNWR box, replacing the gates at the same time. This box served the freight-only south Staffordshire line from Walsall through Wednesbury to Dudley and Stourbridge. (Author's Collection)

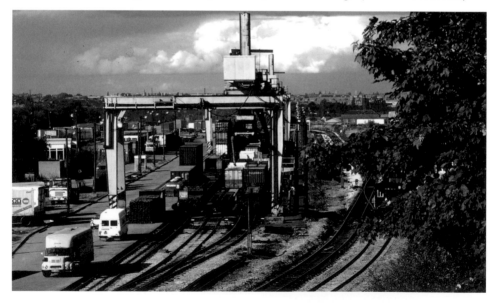

Dudley Freightliner Depot
The 1960s saw an increase in container movement by train and the building of purpose-built depots across the country where the containers were transferred to road transport. With the closure of Dudley passenger station, the site was redeveloped as a freight liner terminal. There were two in the Birmingham area, this depot at Dudley and another at Landor Street in Birmingham. Despite its initial success, Dudley was eventually closed, leaving only Landor Street. (Author's Collection)

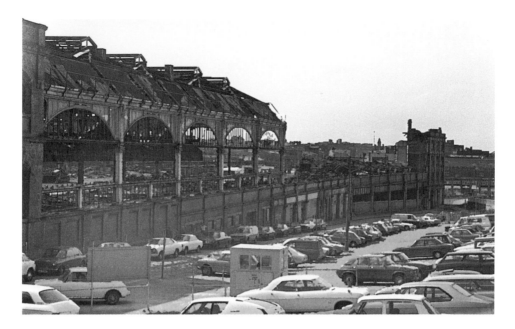

Birmingham Snow Hill Demolition, 1977
Snow Hill used to run down the side of the station, but with the redevelopment of Birmingham's roads in the 1960s, Snow Hill Queensway was moved further east, leaving a space that was adapted for car parking. (Author's Collection)

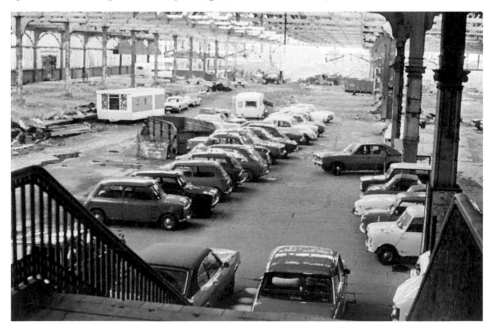

Snow Hill Station, Birmingham
British Railways transferred all services across to New Street between March 1967 and 1968, and ceased all services in March 1972. This vast structure became a car park, and during this period all platform buildings were demolished, leaving the roof in place. In these views the extent of structural ironwork supplied can be appreciated. (Author's Collection)

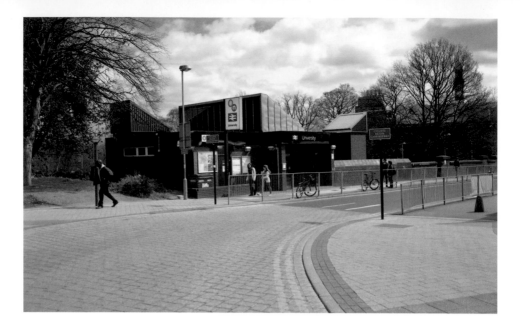

University Station, British Railways

British Railways' first railway improvement for the West Midlands was the upgrading of the Cross City line from Longbridge to Four Oaks and Lichfield in May 1978. This work included new stations at Longbridge, University and Five Ways, as well as improvements at Northfield, Kings Norton and Selly Oak. (Author's Collection)

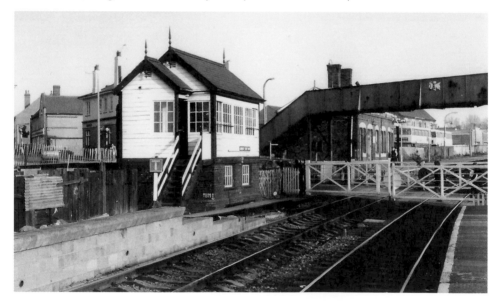

Cradley Station Reconstruction

Cradley was the original passenger terminus of the Stourbridge Railway, whose buildings can be seen beyond the level crossing. The main buildings were placed alongside the line from Stourbridge on a narrow strip of land adjacent to the road. The platform at this station was 'staggered', that is the Stourbridge departure platform was placed on the opposite side of the crossing to the arrival platform. (Author's Collection)

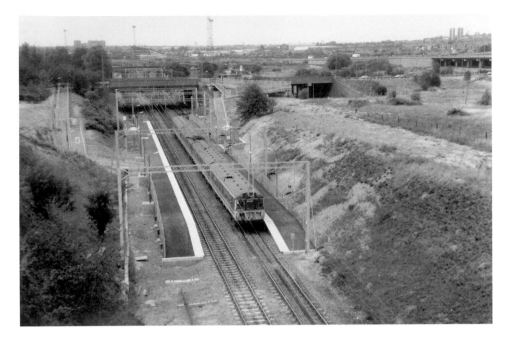

Tame Bridge Station, British Rail
Tame Bridge platforms were erected for the new service between Birmingham and Hednesford through Walsall. (Author's Collection)

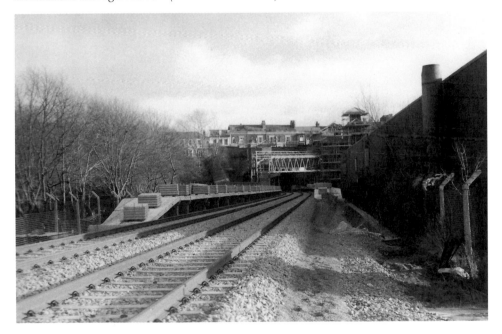

Jewellery Quarter Station, British Rail
The building of a new station at Hockey was done as part of the Jewellery Line project. In this view the station is shown under construction alongside the newly relaid tracks and before the making of the West Midlands Metro, whose route required taking over part of the adjacent Key Hill cemetery. (Author's Collection)

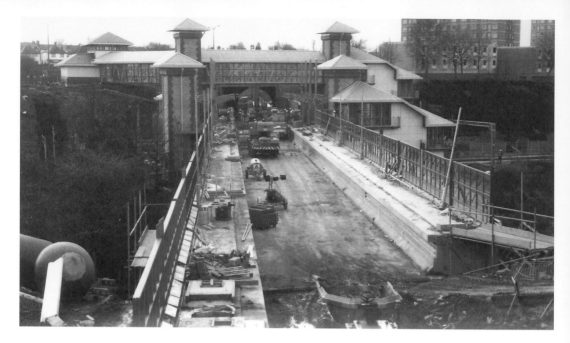

Galton Bridge Station, British Rail
The Jewellery Quarter line crossed the Stour Valley line at Galton Bridge. This view shows the station under construction. The railway was first opened as the Stourbridge Extension. (Author's Collection)

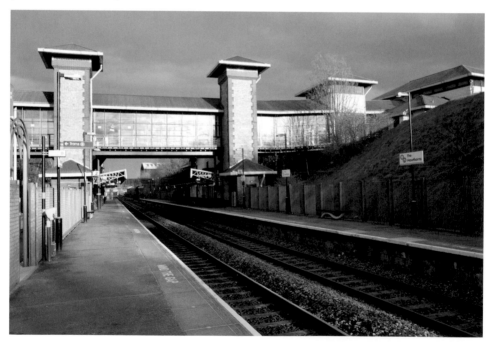

Hawthorns Station, British Rail
The Hawthorns station was also completed as part of the Jewellery Quarter line. (Author's Collection)

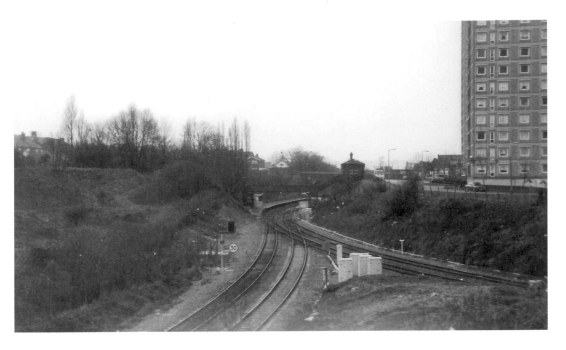

Smethwick West Station and Junction
The opening of the Jewellery Quarter line led to a diversion of train services to Snow Hill, and the closure of Smethwick West station. (Author's Collection)

Wolverhampton Steel Terminal, British Rail
The changing nature of freight traffic led to the closure of many works sidings and the removal of many goods depots. There still was a requirement for certain types of traffic to be delivered to specific points. The movement of steel coils by rail was concentrated at the old GWR Shrubbery goods depot, and utilised the link from the Stour Valley to Monmore Green canal interchange basin to reach it. (Author's Collection)

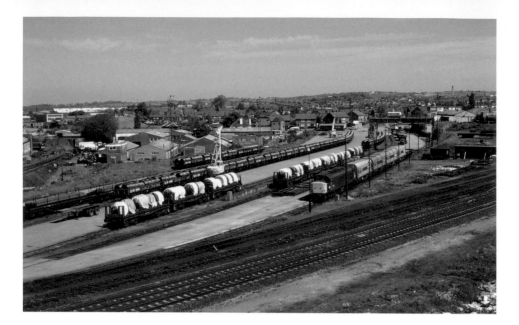

Brierley Hill Freight Terminal, British Rail
Working steel up to finished products was once a staple local trade, and these sidings full of steel trains reflect that former position. It guaranteed a variety of traffic along the former Oxford, Worcester & Wolverhampton Railway route from Stourbridge to Dudley. (Author's Collection)

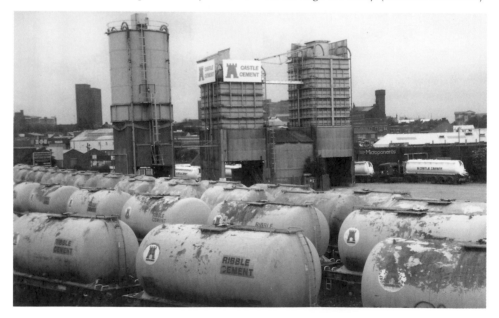

Castle Cement Terminal, Birmingham, British Rail
There was a group of sidings near Curzon Street, known as the Wharf, which were used to store goods wagons, and later, with the conversion of Curzon Street depot into a parcels concentration depot, parcels vans. When the parcels depot was closed, these sidings were adapted as a cement depot. This depot had wagons stored there long after rail traffic had ceased, and they are seen here surrounded by tall grass. (Author's Collection)

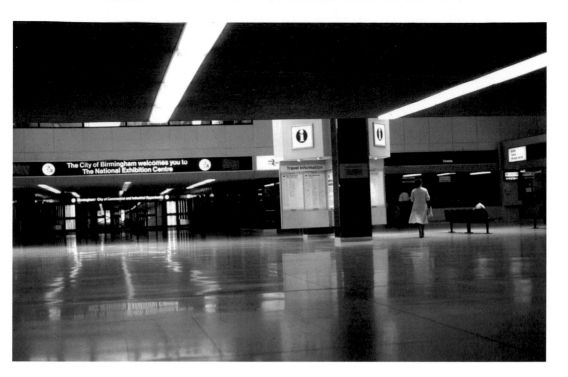

Passenger Concourse, Birmingham International Station
Birmingham International station was opened in 1976 and served the newly completed National Exhibition Centre. It was the first new station to be built in this area since Lea Hall had been constructed (1939). (Author's Collection)

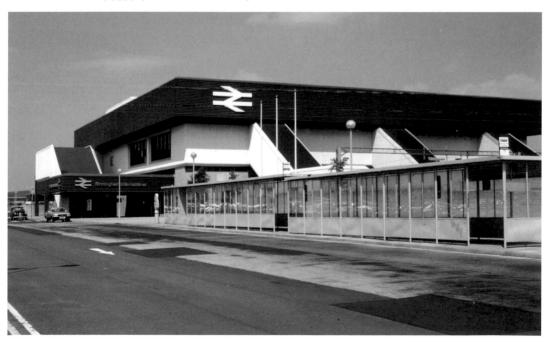

Birmingham International station. (Author's Collection)

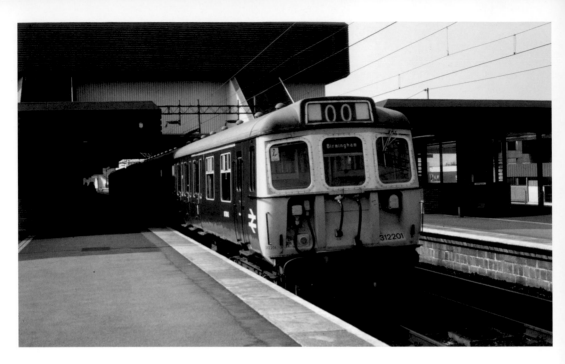

Electric Unit at Birmingham International
Local services were handled by either diesel or electric multiple units. Those on the electrified lines were initially Class 304 and 308 types, but there were some 312 classes before the modern 323 types were introduced. (Author's Collection)

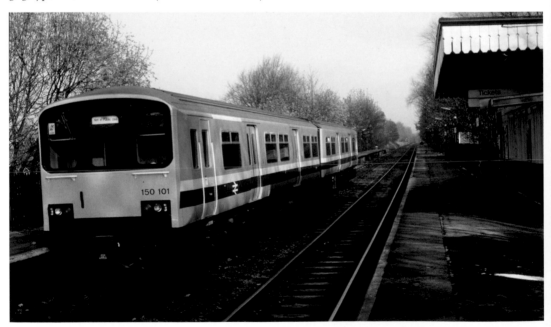

Diesel Unit at Erdington
The early versions of diesel multiple units were replaced on local routes by Class 150 units, principally serving on the lines through Snow Hill. (Author's Collection)

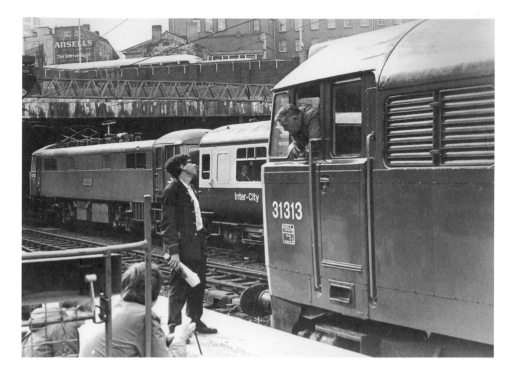

Inter-City Diversity, Birmingham New Street

Many types of diesel and electric traction were once common sights at Birmingham New Street, which became an important interchange point for cross-country and London services. In the upper image are examples of Class 87 and 31 locomotives, and in the bottom image is seen a Class 40 locomotive. (Author's Collection)

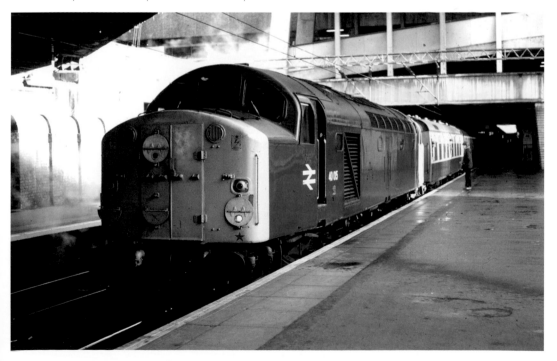

6

Railtrack and Network Rail

John Major led a government that privatised the railways. This process was completed during 1997, and created a complex arrangement of franchised train-operating companies.

Those that served Birmingham and the Black Country comprised Central Trains, Chiltern Trains, North West Trains, Silverlink and Virgin. Both Central and Virgin Trains also leased stations and provided the staff for them. Birmingham New Street was one of a group of large stations which were managed directly by Railtrack, the company responsible for infrastructure and signalling.

Subsequent refranchising has led to several changes in the train-operating section and currently those that serve this region are Arriva, Chiltern Trains, Cross Country, East Midland Trains, London Midland and Virgin Trains.

Soho Depot, Main Train
The siding at Soho became a diesel and electric unit stabling point in British Rail times, and it was here that a team of cleaners was based. With the franchising of Regional Railways Central and the creation of Central Trains (a National Express franchise) in 1997, train maintenance fell to a new business called Main Train. It was this aspect of National Express that looked after the local depots of Soho and Tyseley. At Soho new maintenance buildings were erected. (Author's Collection)

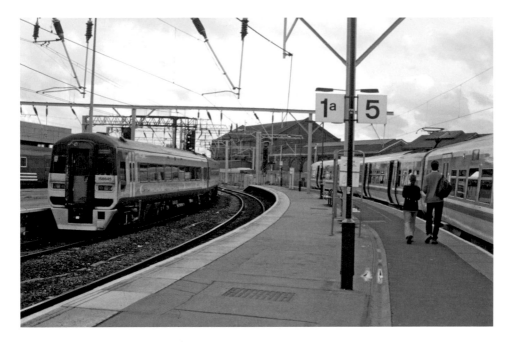

Central Trains Units, Wolverhampton
The first railway franchises allotted Regional Railways (Central) to Central Trains Ltd. They operated most of the local services in Birmingham and the Black Country as well as a number of semi-fast routes. (Author's Collection)

London Midland Unit, Smethwick
Central lost the franchise in 2007 and was split up into three segments. The West Midland local trains were acquired by London Midland, who also took over the Silverlink routes into Birmingham. (Author's Collection)

Langley Green Station
Complete with Centro Logo, the new booking office at Langley Green formed part of the station improvement here that also included a small car park. (Author's Collection)

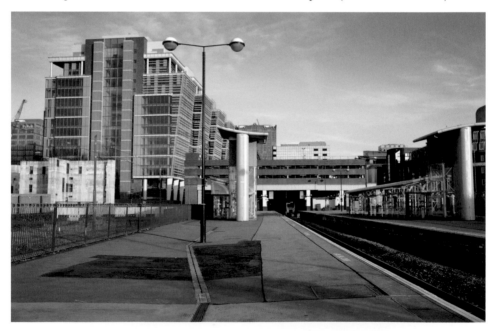

Snow Hill Station, British Rail and Network Rail
Snow Hill was reopened as a terminus in 1987 and became a through station again with the completion of the Jewellery Quarter line. All pedestrian access to the station was either from the top of Livery Street or from a new public space above the railway tracks that faced Colmore Row. A second Livery Street entrance was made later. (Author's Collection)

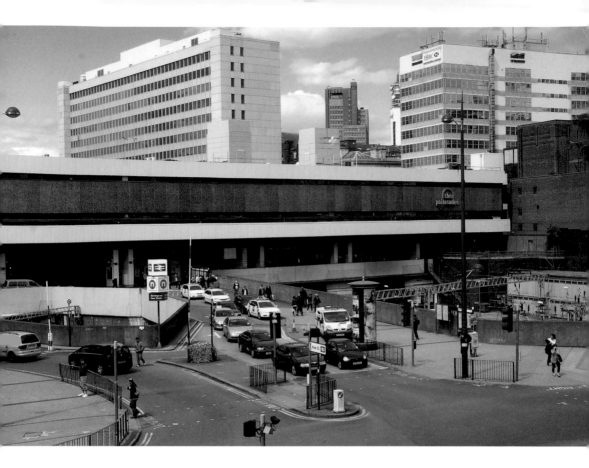

Birmingham New Street Reconstruction

A key new development has been the ongoing reconstruction of New Street station, which will see the creation of a new passenger concourse, a more open structure that replaces the concrete-topped semi-underground station of 1967. Much of this work is of a cosmetic nature; even though a new pedestrian concourse will be completed and passenger access to the platforms improved, no real improvement will be made to platform accommodation – indeed, the former goods bays on the Platform 12 side have been lost to make way for a new store development. Reconstruction work at New Street station is due to finish during the autumn of 2015. Various changes to pedestrian access to the platforms have been made with a gradual programme of installing new escalators and lifts. The new concourse was opened in April 2013, with a second new dispersal bridge coming into use after the Bank Holiday, August 2014 serving platforms 4–11. In October 2014 this new bridge was extended to serve the remaining platforms 2–3.

Meanwhile contractors are working to remove part of the floors of the former Pallasades Shopping Centre to provide a new pedestrian area, flooded with natural light. (Author's Collection)

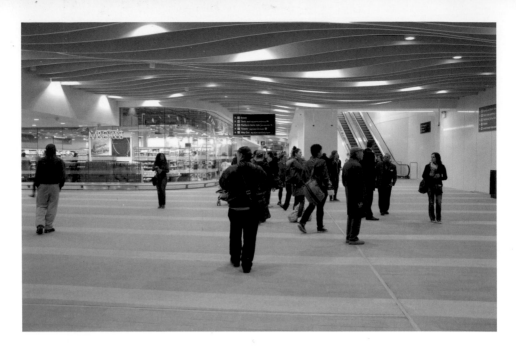

Birmingham New Street Reconstruction, 28 April 2013
The first phase of New Street redevelopment happened amid great publicity, when the new concourse was opened on Sunday 28 April. This marked the completion of Phase 1; another two years will be required to finish Phase 2 – the relocation of the Pallasades shopping centre to a new level. (Author's Collection)

Birmingham Moor Street
Chiltern Railways reinstated two of the original platforms at Moor Street. (Author's Collection)